Management
of Art Galleries

MAGNUS RESCH

For my father

Foreword

Art dealers who focus less on business and more on art are generally the dealers who become the most successful and influential. Over the years, I have watched many art dealerships that have been set up as conventional businesses fail within a few years of opening after incurring enormous losses. I have also watched people with little regard for accepted business practices, but with exceptional artistic vision, build thriving galleries.

One of the most interesting younger dealers told me that he never sends promotional emails and never solicits collectors, waiting for potential buyers to make the effort to contact them. Contacting the gallery is not easy because there is no phone number on their website and no section with available works. There is no name on the gallery door, which is almost impossible to find unless a knowledgeable friend takes you there. In spite of these obstacles, the gallery's ability to find promising artists and provide them with an exciting context has serious collectors clamoring to buy the work.

Is there a model for the successful art gallery? The most important galleries invent their own model. The best galleries also reflect the personality of their owners. Gallerists who are intellectual and reserved can be as successful as dealers who are outgoing and socially adept. Galleries that look like a mess with a chaotic back room can be as successful as an immaculate gallery with obsessively organized painting racks. What is important is for the gallery to embody a genuine personal vision. When galleries become too corporate they tend to loose their edge.

The gallery that opens trying to emulate the most successful gallery of the previous decade will probably not become as important as the gallery that pioneers a new neighborhood, finds a new type of building, or develops a fresh approach to the art experience. Aggressive sales people cannot make up for a lack of artistic vision. The galleries that inspire

collectors often sell more than the galleries that pursue potential buyers with conventional sales strategies.

One often hears complaints that the auction houses, the art fairs, and the mega galleries are destroying the special quality of the art business. But despite these challenges, remarkable new galleries keep emerging. There are now probably more interesting new art galleries in more cities than ever before. The best of these aspiring dealers intuitively understand that running a gallery is not just a business; it is a life. At its best, the art gallery is a creative enterprise that transcends business. It becomes an essential part of the process through which new art becomes art history.

Jeffrey Deitch

1

Introduction

The art industry is cool, sexy, and over-flowing with money. Oh, no, hold on. It is an edgy, gritty world, with painters and sculptors who would die for their art, caring nothing for money but passionately committed to their artistic meaning.

Both images have origins rooted in myth and in reality, but the more glamorous picture is the one that is grabbing all the headlines. Everything about the elite end of this market is enormously alluring. We read about millions of dollars pouring into the market, the dizzying levels reached at auction battles, and the rich and beautiful at opening events.

The reality can sometimes bear about as much similarity to this seductive image as an artist's garret has to a luxury penthouse. The art world is tough, the rules are a complete mystery to the uninitiated, and only the lucky few make money. Life in the art market means being constantly torn between culture and commerce, and nowhere is this more effectively illustrated than in art galleries. They are the institutional gatekeepers to the art world and all its paradoxes.

Gallerists are the most vital intermediaries in the art market.

Art galleries are part of an exclusive social calendar, with exhibition openings hosting a select and sophisticated crowd. They are also a big part of the cultural life of a city. They support young artists, helping them to develop, they arrange exhibitions that attract collectors, and they manage collections when artists die. They are, in short, the most vital intermediaries in the art market.

Given their importance, surprisingly little is known about the economics of art galleries, with art and business remaining reluctant bedfellows and money talk kept to the back room. What we do know is that, unlike art museums, art galleries do not receive state subsidies—they are a business, as much a commercial entity as any small shop, with a clear business focus and a revenue model that lives or dies by sales. And, of course, they are subject to all the same market fluctuations, limitations and opportunities as other entrepreneurs.

Gallery owners have long neglected the importance of management practices in their businesses. They have seen themselves as blissfully immune from any of the irritants visited on other markets such as inefficiency, customer failure to pay bills or bankruptcy. Trying to impose business thinking

on art galleries was considered a violation and contamination of the happy planet of the art world. German art dealer Aenne Aebels summed up this most individual of business ideologies decades ago: 'Our business has an aura and you are destroying it when you write about business stuff.' Not much has changed.

It seems, however, that art galleries have run out of road, and economic realities have caught up with owners. Dropout rates in the market are very high, and not just among smaller businesses. Los Angeles dealer Margo Leavin, representing John Baldessari and William Leavitt, announced that she would close after forty-two years. McKee Gallery in New York shuttered its doors in August 2015 after forty-one years. Paris dealer Jérôme de Noirmont, representing Jeff Koons, George Condo and Shirin Neshat, closed his Avenue Matignon premises. And Berlin was aghast when Martin Klosterfelde and Galerie Kamm announced that they were closing down.

Why are art galleries in such poor shape?

There is no doubt that the hurdles for a traditional gallery system are getting higher. High markups, heavy local costs for promotion and rent in a market facing increasingly inter-national competition, expensive art fairs, a few übergalleries that poach the successful artists, and auction houses that expand into the primary market or sell privately. It seems that with the exception of a handful of big galleries, those who continue their presence in the market seem to generate only small profits or even losses.

So why are art galleries in such poor shape? The answer is simply this—their business model hasn't changed with the times. Other industries have seen rapid changes in the past twenty years, while the art market has continued to occupy what it still believes is a privileged space. If galleries want to enjoy real success in the future, they need to shine a very harsh light on their business practices. They need to analyze their business models and ask themselves questions. What do

EXAMPLES OF CHANGING
BUSINESS MODELS

INDUSTRY	EXAMPLES
Transportation	Low cost airline (Ryanair, Spirit, Jet Blue)
Finance	Direct banking (First Direct, Capital One 360)
Telecommunication	Mobile communication (Virgin Mobile, WhatsApp)
Automotive	Car sharing (Zipcar)
Textile	Redesign of value chain (ZARA)
Music	Distribution of music (iTunes)
Wholesale	Category management (Walmart, Amazon)
Retail shopping	Online ecommerce (Zappos, Zalando)
Art market	—

Fig. 1

customers really want? How can a firm get paid for (and profit from) meeting their needs? There's no shortage of industry examples to illustrate how addressing these questions can stimulate change. iTunes, for example, changed the distribution of music; Zappos.com went online and transformed the traditional brick-and-mortar, central location model of retail. While the world changed, the art market—well, it just remained the same.

This book offers a practical management approach to real improvements in the gallery business. It gives valuable insights into the art market, presents and classifies its players, and for the first time develops an economically sound and sustainable business model for art galleries. Nor does it stop at analysis and a theoretical model. I also implemented the model in three galleries, to test my ideas and work out where my approach needed to be slightly adapted. The results show that this model works. Throughout this book, vivid examples from other best-practice case studies, as well as tables and graphics, will help practitioners to improve their own model.

My results are based on a decade's worth of research, a project I undertook specifically to generate enough understanding to configure an appropriate business model for art galleries. I surveyed more than eight thousand galleries worldwide. This research took me to gallery hotspots ranging from the streets of Chelsea, New York, to London's East End, to Berlin Mitte, to Bahnhofstrasse Zürich, and to Central, Hong Kong. I visited art fairs and museums, and interviewed some of the world's most well-known art industry experts. The key question was always the same: what are the success factors of an art gallery?

But beware: I haven't found the holy grail, and this book is not going to help you invent the iTunes for the art market or the Amazon for the art world. Nor can the ideas presented here be just slavishly copied and mapped directly onto your

business. Each gallery has to decide for itself to what extent it applies the proposals. They serve as a guideline, rather than as rigid principles. There are also plenty of perfectly successful galleries following a totally different approach, but they do not form the subject of this book. In my view, the approach in the following pages is the most useful, and the most easily replicated. Whatever the outcome, this book will help in approaching the art market with an unbiased view and spark a rethink of existing business practices.

Before we start to draw our new model for art galleries, I want to talk about three things:

(1)

The relationship between management and the arts.

(2)

Evidence to support the argument for more management in the arts.

(3)

The methodology behind this book.

2

Management —Don't Be Afraid

Management, business models, and profit have already been mentioned a few times. Those who raised their eyebrows (and who are still reading)— stick with me. These are not dirty words, nor are they incompatible with the arts.

Discussion of the impact of management and business principles on the arts has produced much heated debate over the last few years, among practitioners as well as academics.

Critics claim that an intense focus on management and the processes that accompany it might infect works of art and reduce creativity. Artists fear that no real value will be created in the future, and exhibitions will not generate new artistic insights but just add to the general dumbing down of society. Losing value as a consequence of management is a common prejudice and a deep-rooted underlying attitude in discussions on management in the arts. I experienced this firsthand when the first edition of this book came out in 2015. The feedback was mixed. While the business press, such as Bloomberg, applauded it and praised the findings, others (for example, a blog called Hyperallergic) simply hated it.

Professional management in art institutions has a positive impact and does not flatten out artistic quality.

In the debate over corporate sponsorship for the arts, critics are particularly vocal. They warn museums that they will become dependent on the money of corporate firms, whose aim is to take control of the program and its content. Practitioners fear that the success of an art institution will be measured in visitor numbers, and only those with the highest figures will be granted state subsidies. Others have a vision of marketing experts hovering with marketing toolkits developed over years of thinking about toothpaste and laundry detergent, ready to impose their consumer goods experience onto the arts.

On the other hand, a new understanding of the role of management in the arts is developing, particularly among US and UK galleries. The Arts Council in Britain has proved in a longitudinal study (1998–2003) that management principles have a positive impact on the arts. Their final report argues that art institutions must fulfil two purposes: they must create artistic, meaningful, highly appreciated exhibitions, and

they must consider profit by employing professional management to attract new customers.

Additionally, other research and examples highlight that professional management in art institutions has a positive impact and does not flatten out artistic quality. On the contrary, they leverage it and bring it to a new level, making it accessible to a greater audience. A study by A. T. Kearney, an international consultancy, specifies three core principles for the success of an art institution: (1) professional management, (2) additional revenue streams, and (3) an active role in a network.

Nor are consultants and academics alone in promoting a focus on management in the arts. The museum world also shows that these principles lead to practical success. The Schirn Kunsthalle in Frankfurt is a best-practice exemplar for an art institution that has successfully implemented strong management tools without compromising on quality. Former director Max Hollein (who has now left to take on a role at the Fine Arts Museum in San Francisco) frequently explains that economic concepts and strategic approaches lead to positive results. He considers his museum an enterprise that adapts business principles to produce excellent artistic exhibitions. He measures success in terms of quality and the impact of the message the current exhibition communicates. For Hollein, then, efficiency and effectiveness are key characteristics of a successful museum.

Andy Warhol, Richard Prince or Jeff Koons used marketing tools as strategic practice.

Other examples were perceived as less successful. Observers at MOCA (the Museum of Contemporary Art, Los Angeles) feared that director Jeffrey Deitch was tilting the museum too far towards the pop culture emphasis he had pioneered at his gallery. When he announced plans for the exhibition *Fire in the Disco*, the resulting fallout saw the resignation of all four artists on the MOCA board, including Ed Ruscha and Barbara Kruger. After Deitch's eventual departure in July 2013, there was no shortage of critics

arguing that a businessman—even a successful art dealer with an MBA from Harvard Business School—cannot run a non-profit institution.

Interestingly, management principles have filtered down even to the artists themselves. Successful artists such as Andy Warhol, Richard Prince or Jeff Koons used marketing tools as strategic practice. They created a recognizable look, name and style—in other words, a brand. Successful artists can be thought of as brand managers, actively engaged in developing, nurturing, and promoting themselves as recognizable products in the competitive cultural sphere.

The best example is probably Damien Hirst, whose instinct for marketing has made him the richest artist the world has known. Hirst's wealth is estimated in the $400 million to $600 million range. At the age of fifty something, he is worth more than Pablo Picasso, Andy Warhol and Salvador Dali combined at the same age. I cite here three examples of his highly inventive commercial and creative thinking.

Damien Hirst's instinct for marketing has made him the richest artist the world has known.

In the primary market, new works are traditionally shown by the dealer, then may be auctioned after a period of some years. In 2008, Hirst broke with this tradition, bypassing his major dealers Gagosian in New York and White Cube in London to offer his works directly through a Sotheby's auction—on the day Lehman Brothers announced bankruptcy. The auction was a great success, with 216 of the 223 works (estimated at $122 million to $176 million) selling for a total of $198 million.

Hirst also uses language. One of the most simple marketing techniques is to put a fancy name on an ordinary product. If Hirst's shark were just called *Shark*, the viewer might move on. Calling it *The Physical Impossibility of Death in the Mind of Someone Living* challenges the viewer to stop, to read the text again, and eventually to consider the work in the context of the title.

Finally, Hirst has also used a well-judged sense of hype with artistic display and drama. The skull with 8,601 small industrial diamonds, titled *For the Love of God*, wasn't just shown in a gallery. It was displayed, almost like a relic, upstairs at White Cube, in a dark room with only a spotlight on the skull. Entry was strictly by timed ticket, with people lining up for hours to enter. The piece was featured in every newspaper around the world and was (apparently) later bought for an unknown price by a consortium that included Hirst himself.

Considering that even non-profit organizations and artists have got on board with management practices, art galleries, as profit-oriented enterprises, should not be above joining them. The intellectual, disciplinary and semiotic separation of art and business should no longer obscure the potential of management tools in gallery practice, and my new model is firmly rooted in placing increased emphasis on those tools in communicating the arts.

However, I am aware of its limitations. Management principles have to be implemented with some sensitivity to the specific market and its climate, and they can't all be trans-ferred to the art market. This book is at pains to merge management practices with existing practices and characteristics of the art market. In fact, this new gallery model emphasizes the balance between artistic quality and management orientation.

Number
Crunching

So are art galleries really so financially precarious?
Do we really need to change the business model of art galleries?
I believe so.
Galleries don't make enough money and are blindly—and stubbornly—clinging to an outdated business model.

Unlike other sectors within retail, whose difficulties have been extensively scrutinized throughout the economic downturn, the struggle for galleries to generate profit seems to barely scratch the surface of public awareness, and I can only speculate as to why. There is, admittedly, next to no statistical information, and the little market intelligence that circulates usually lumps art galleries in with other fields: stamp and coin dealers, gift articles, and so on. Researchers therefore have only very limited insights at their disposal, and have to rely heavily on estimates for analysis or interpretation of existing statistical data.

A carefully constructed aura of success is almost certainly one of the factors obscuring gallery finances. Galleries have for decades created the impression of being high-class, elite businesses generating a decent income. Who would want to buy art from an almost bankrupt business that cannot pay the caterer's invoice from last week's opening? Or from a gallerist whose artist is threatening him with a lawsuit because he has defaulted on the artist's share of sales from the last year? Or from someone who has employed five people for over two years but pays them an intern's salary? Art needs a bit of mystique to uphold its value, an impression that is somewhat undermined by tax officials and a rattling petty cash box.

Who would want to buy art from an almost bankrupt business that can't pay the caterer's invoice?

But it is not only the gallerist and the scarcity of information that uphold this false impression of discreet wealth. Banner headlines on spectacular auction prices add to a widespread belief that art galleries are pure profit generators. With global sales of $64 billion in 2015 and seemingly unstoppable price escalation, you could be forgiven for thinking that every player in the art market must be getting a share from this money-making machine. Particularly, the contemporary market (where nine in ten galleries compete) is under constant media scrutiny. Excitement is fuelled by a whole new generation of collectors. Their aggressive bidding has

multiplied the total annual auction revenue from contemporary art since 2005 from $824 million to $6.8 billion.

Not surprisingly, these phenomenal market conditions, the lack of independent market analysis, and the traditional projection of wealth that gallerists are at such pains to preserve combine to prevent any alarm bells ringing about such mundane matters as balance sheets. However, as we will see, the reality is somewhat different.

To get a better understanding of the market, I set out in 2009 to conduct a survey among all galleries in Germany. The results of this survey are included in an earlier edition of this book. For this edition, I wanted to increase the number of participating galleries and so undertook an exhaustive survey of eight thousand Fine Art galleries in the USA, UK, and German markets—the three markets that are the largest in terms of gallery numbers—in the autumn of 2014. This chapter, and the rest of the book, draws on this data.

REVENUE

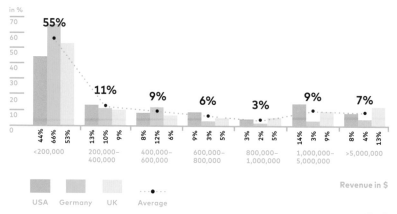

Fig. 2

Stru**3.1**ural Data

Revenue in the art gallery market in the USA, UK and Germany is low, with 55% of all galleries producing revenues below $200,000 a year. Revenue figures, moreover, are quoted inclusive of the artist's share; when the usual fifty-fifty commission split is applied, only 50% remains with the gallery, the remainder going to the artist.

At the top end, 16% of glleries achieve revenues over a million dollars, and 7% exceed $5 million. Clearly, then, a few galleries do make money.

A breakdown by country shows noticeable regional differences. The USA and UK are clearly busier than Germany at the top end, with 22% of US and UK galleries making over a million dollars in revenue. In particular, the UK seems to generate the highest revenues: 13% make more than $5 million, compared to only 4% in Germany. At the other end of the scale, 66% of German galleries produce less than $200,000 a year, an annual revenue bracket occupied by only half the gallery population in both the USA and the UK.

Taking auction results as an indicator of market conditions, the economic context for these numbers is strong; 2013 was, in fact, highly successful. Auction sales reached $31 billion, up 5% year-on-year and only slightly below the 2007 peak of $33 billion. There was seemingly little turbulence, and no particularly severe market conditions that might have caused low revenues. The high number of struggling—or failing—galleries therefore seems to be a structural or industry-specific problem, rather than the product of a sluggish or volatile economy.

The differences between the countries are admittedly surprising. The USA and UK outperform Germany by some distance. In theory, Germany should be fertile ground for those who want to make a career in art dealing. The country is justifiably proud of its art scene, with a major landscape of important museums, galleries and collectors. In economic

terms, this huge supply should suggest a huge demand. In reality, however, demand is much weaker than in the two other countries. Collectors do not buy in German galleries, nor, it seems, in German auction houses; according to *Art Market Report*, while the USA and UK account for 34% and 17% of global auction sales, in Germany this falls to just 2%.

Profit paints a similarly downbeat picture. While 30% of all galleries operate in the red, 18% make a healthy profit margin of over 20%. In other words, at the top end, a few galleries have worked out how to run a highly lucrative gallery space. At the lower end, however, there is a sea of galleries that produce little profit—or none at all. Germany's gallery distribution is particularly weighted towards poorer performers, with 34% running at a loss, compared to 29% in the USA and 23% in the UK. At the more profitable end, meanwhile, only 9% of Germany's galleries have profit margins above 20%, compared to one in four in the UK.

The participant group in the survey had already been narrowed down to those that sell fine art, which is the dominant cluster in the art market, leaving decorative art and antiques far behind. Galleries were asked to describe their product split across five different categories, or sectors:

PROFIT

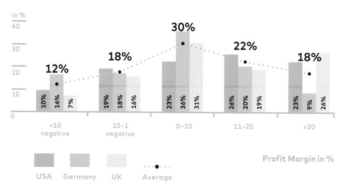

	<10 negative	10–1 negative	0–10	11–20	>20
Average	12%	18%	30%	22%	18%
USA	10%	19%	23%	26%	23%
Germany	16%	18%	36%	20%	9%
UK	7%	16%	31%	19%	26%

Profit Margin in %

Fig. 3

Artists born after 1960
Artists born after 1910
Artists born between 1875 and 1910
Artists born between 1821 and 1874
Artists born before 1821

Unsurprisingly, the USA, UK and Germany primarily deal in contemporary art. An overwhelming 93% of all galleries in the survey sell contemporary art; 23% also trade in modern art, and 16% in post-war art. Nineteenth-century art is sold by 10%, and only 5% deal in Old Masters.

Filtering out Germany, the product mix is more diversified in the USA and UK, with modern art sold by around 30% of galleries. In Germany, this figure drops to 15%, but their contemporary art presence is marginally above average, with 97% dealing in contemporary art (with or without other categories alongside them). Galleries in the hubs follow suit.

GALLERY FOCUS

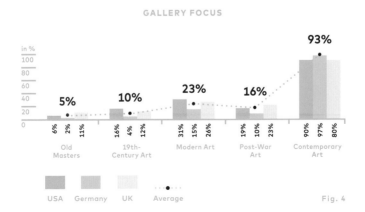

Fig. 4

Competitors and Collectors

3.2

Competition is a critical factor in any market where supply exceeds demand, and competitors to art galleries come from every corner. There are direct competitors (other galleries), their suppliers (artists), their business partners (dealers); and there are other market players that have been around for varying periods of time, but who are now entering the competitive landscape in force (auction houses and online platforms).

Galleries were asked to rank these key competitors. Since most galleries offer specifically contemporary art, they rank other galleries as their primary competitors, followed by dealers. It was a surprise to see artists ranked in third place, but many artists sell some of their output privately through their studios, cutting out the gallerist's margin. Placing them above auction houses suggests the frustration among gallerists that they have not found a way of preventing artists from cannibalizing their trade. Auction houses rank fourth, and online platforms are considered the fifth most serious—or the least serious—competitor.

RANKING OF COMPETITORS

	USA	GERMANY	UK
OTHER GALLERIES	1	1	1
DEALERS	2	2	2
ARTISTS	3	3	3
AUCTION HOUSES	4	4	4
ONLINE PLATFORMS	5	5	5

Fig. 5

In a time of such frequent new art start-ups, it is surprising that galleries are not beginning to see online platforms as a serious threat. To date, most online platforms have partnered with galleries on a commission basis to display a selection of the gallery's portfolio, and are therefore seen as partners (for example, artsy.net or artspace.com); other online platforms that cut out the gallery as intermediary between artist and buyer (for example, saatchiart.com) usually serve a separate, and often lower-end, client base, so are not regarded as competitors for the same clients.

In times when competition is severe, galleries stand or fall by the conversion rate of visitors to buyers. Visitors may flock through the doors in their thousands, but buyers form a tiny fraction of their number. Visitors are classified into five groups:

OPENING CROWD:
Interested in the event
ART ENTHUSIASTS:
Frequently visit galleries but have no intention of buying
COLLECTORS:
Buy works of art

RANKING OF VISITORS

	USA	GERMANY	UK
ART ENTHUSIASTS	1	2	1
OPENING CROWD	2	1	2
COLLECTORS	3	3	3
WALK-INS	4	4	4
ART PROFESSIONALS	5	5	5

Fig. 6

WALK-INS:
Do not set out to go to a gallery, just enter on impulse
ART PROFESSIONALS:
Artists, dealers, critics, museum directors and so on

The most frequent visitors to the gallery are the Art Enthusiasts and the Opening Crowd. Neither has any interest in buying art but come either to see the art or to socialize. For a business that needs to sell, these visitors are certainly part of the life of a gallery, but they have no impact on revenue. The most valuable group of visitors, Collectors with the potential to buy, are ranked third. Ranked fourth are Walk-ins. Given the passing footfall in the central locations where most galleries are found, the persistently low number of Walk-ins is remarkable, and it suggests that there are still strong psychological barriers in the public's mind to entering a gallery. Art Professionals are the least frequent visitors, and as a group they include artists who would like to introduce their work to the gallery.

Buyers can be divided into six categories, each with different motivations:

ART LOVERS:
Buy for the love of art, to extend their collection, or as a source of inspiration
ONE-TIME BUYERS:
Buy to signal (or to aspire to) social status, or for decorative purposes
DEALERS/PROFESSIONALS:
Buy to resell or in the name of a client
INVESTORS/SPECULATORS:
Consider art as an alternative investment, art flippers
MUSEUMS/FOUNDATIONS:
Buy for permanent display
CORPORATE COLLECTORS:
Corporations such as UBS, Deutsche Bank, JP Morgan Chase and others

The most frequent buyer at an art gallery is the Art Lover, who represents the old-school type of collector. A perfect (and often quoted) example are Herbert and Dorothy Vogel, who spent most of their money collecting art. Over thirty years they amassed an astonishing collection of 4,500 artworks, stored in their one-bedroom apartment. As their collection grew, they got rid of their sofa to make space. Art Lovers are keenly interested in the development of artists and usually have a lasting and strong relationship with the gallerist. The Art Lover is the cornerstone of any gallery's success.

The second group in the list comprises One-Time Buyers. They usually do not establish a lasting relationship with a gallery, and they disappear as quickly as they emerged. However, they are ranked in second place, and are a valuable source of revenue.

Ranked third are Dealers/Professionals, followed by Investors/Speculators. Naturally, there is a degree of overlap between those who love art and those who see profit in a

RANKING OF BUYERS

	USA	GERMANY	UK
ART LOVERS	1	1	1
ONE-TIME BUYERS	2	2	2
DEALERS/ PROFESSIONALS	4	3	3
INVESTORS/ SPECULATORS	3	4	4
MUSEUMS/ FOUNDATIONS	5	5	5
CORPORATE COLLECTORS	6	6	6

Fig. 7

purchase. The Mugrabi family, for example, are passionate art collectors but also have a strong interest in its business potential. In the USA, Investors/ Speculators rise to third in importance, explaining the prominent media coverage of 'art flippers'—such as Stefan Simchowitz, who has become almost synonymous with the phrase, such is his notoriety as a hit-and-run investor—and Wall Street icons who treat art as an asset (and are willing to resell, fast).

Stefan Simchowitz has become almost synonymous with the phrase 'art flipper', such is his notoriety as a hit-and-run investor.

In all three countries, the remaining institutional buyers occupy fifth and sixth positions: Museums/Foundations, and finally Corporate Collectors. Despite their position as the least frequent buyers, the budgets that major firms are now allocating for their art foundation are not without significance. Deutsche Bank, JP Morgan, Chase and Bank of America are only some examples of companies with heavy-weight art collections.

Cost Structure

Severe competition and a growing customer base, yet second-rate or worse revenues and a slim profit margin raises several questions about the cost structure of art galleries. Galleries were asked to rank their costs from a specified list of items.

RANKING OF COSTS

	USA	GERMANY	UK
RENT (GALLERY + WAREHOUSE)	1	1	2
SALARIES	2	3	1
ART FAIRS (WITHOUT TRANSPORTATION)	4	2	3
TRANSPORT	3	4	4
INSURANCE	5	5	5
ADVERTISING	6	6	6
IT	7	7	7
LAWYER, CONSULTANT, CRAFTSMAN	8	8	8

Fig. 8

On average, rent is generally the highest overhead for galleries, with salaries, fairs and transportation costs falling into second, third and fourth place. A country analysis shows some specific variations. All other costs, including advertising and insurance, are identically ranked in positions five to eight.

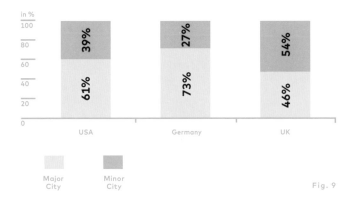

Fig. 9

Major City | Minor City

NUMBER CRUNCHING

Because most galleries are located in premium locations in major cities, rent remains a high cost in a country breakdown, although in the UK payroll is a slightly bigger burden. Salaries in the USA are the second highest overhead, and in Germany the third highest. Although salaries may be pushed into third place by the German tradition of higher expenditure on art fairs, German employees in particular might agree with claims that pay in the sector—at least in some regions—is too low. Art fairs are ranked third in the UK and only fourth in the USA.

Unsurprisingly, rent always features as one of the top two overheads for galleries. Gallerists cling passionately to the belief that they must set up shop in a central location in a major city—in other words, where rent is highest.

By country, this trend is at its most visible in Germany. More than 70% of all German and 61% of US galleries are in major cities, compared to only 46% in the UK—explaining why rent is not the highest overhead in the UK.

It is difficult to establish the precise motivation of gallerists to locate in costly central premises. A gallery in a decentralized location can be as successful as a gallery in the busiest city street. The almost unanimous, and unquestioned, conviction that central premises in a major city are essential simply

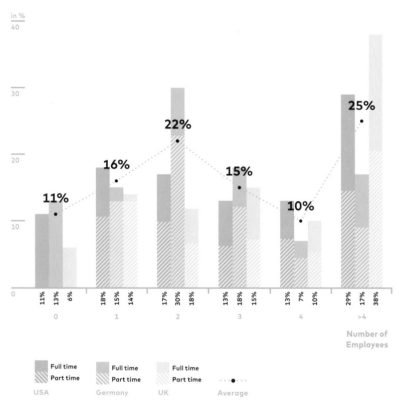

Fig. 10

cannot be justified with an economic rationale; to some extent, it can be explained by tribe mentality, but it also reflects concerns about reputation, visibility and brand building.

Salaries are another leading expense, according to gallery owners. In a business environment where there is little opportunity to turn to automation or outsourcing, running a gallery is always likely to require a great deal of personal input, and might therefore be expected to have a heavy payroll burden. In practice, however, art galleries are small enterprises in

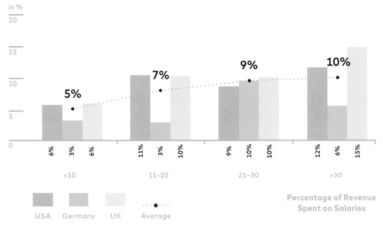

in %

20

15

7% 9% 10%

10 5%

5

0

6% 3% 6% 11% 3% 10% 9% 10% 10% 12% 6% 15%

<10 11–20 21–30 >30

USA Germany UK Average

Percentage of Revenue
Spent on Salaries

Fig. 11

NUMBER CRUNCHING

terms of employment numbers. A companionless 11% of
gallerists run their business with no assistance, and only 25%
employ more than four people.

Employing full-timers is evidently not common practice at
art galleries. Overall, 40% do not have a full-time employee—a
strategy that is particularly visible in Germany—and only a
small minority of 8% have more than four full-time employed
staff members.

In general, galleries are reluctant to employ large numbers
of employees and pay them well. It would appear that salaries,
already seen as a high overhead, are a significant fear factor,
and keeping salary costs low seems to be the first rule in the
gallery employment market. However, galleries should rethink
this paradigm. The results from the survey suggest that
profit margins grow exponentially with the number of
employees. While galleries running without assistance
typically show an average profit margin of 3%, those with one
employee typically yield twice this result. Galleries with four
employees can even triple this rate and bring the business to a
profitability margin of 9%.

Profitability versus percentage of revenue devoted to salaries illustrates a similar result. Put simply, galleries spending a large amount of revenue on salaries achieve higher profit margins than those who do not. While spending less than 10% of revenue on salaries produces a 5% margin, spending more on salaries often results in higher profitability.

This all provides a much more illuminating and fact-based picture of the market than we have had to date. But it also raises some questions. Why do galleries spend so much on rent? We know that most visitors are Art Enthusiasts and the Opening Crowd, who have no intention of buying. Collectors, who do buy, come in third behind them, and this group are less concerned with being in the city centre than they are with getting a good parking space.

Very few galleries make really good returns, and the majority are at best only marginally profitable, if at all.

Another question is why so many galleries focus on contemporary art, where competition is at its steepest. Most galleries will cite other galleries as their primary competitor. In a market where everyone offers the same product, it is hard to find ways to differentiate oneself. And why do galleries employ so few staff? The data shows that profit tends to grow exponentially according to the number of staff.

An answer to these questions might explain one of the biggest paradoxes among galleries: very few galleries make really good returns, and the majority are at best only marginally profitable, if at all. This was the starting point for my research and leads to the next chapter.

My
Research
Approach

When I first published this book in August 2014, almost every newspaper wrote about it. It was a number-one bestseller on Amazon for several months, and I received a landslide of emails from readers. The feedback was mixed, to say the least.

Some readers were wholeheartedly in favour, claiming that finally someone was saying what we all knew: that the art market is in need of an overhaul. Others met my ideas for improvement with reluctance. It seems that everyone is an expert. Like football, everyone is the national coach, and everyone has an opinion (from which it follows, of course, that their opinion must be vocalized). The art market is complex, with no clearly defined codes of conduct or regulation. Nonetheless, I believed that the time was right for a new, clearly articulated business model for galleries, and I set out to develop one.

I could also see that anecdotal evidence, while useful, had its limitations. I set out to follow a thorough and highly time-intensive research approach, and spent ten years observing the gallery market through a theoretical and a practical lens. The resulting business model is based on a quadrant of research methods: **(1)** a wide survey of art galleries, **(2)** extensive talks with leading international experts from the art scene, **(3)** case studies featuring galleries and **(4)** secondary sources, including articles, books and papers.

RESEARCH METHODOLOGY

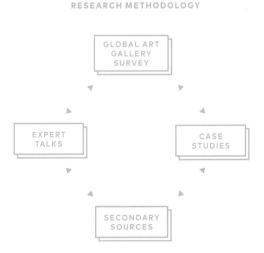

GLOBAL ART
GALLERY
SURVEY

EXPERT
TALKS

CASE
STUDIES

SECONDARY
SOURCES

Fig. 12

As the foundation for the new model, I used the results generated in a quantitative study I conducted among 8000 art galleries. Gallerists are notoriously lazy about answering surveys or replying to emails, so I decided to focus on the three biggest collector markets: the USA, Germany and the UK. This produced a surprisingly high feedback rate of over 16%. Galleries were sent an online questionnaire and were asked to provide some structural data, as well as answer a set of management questions. These results were then plotted against profit via a regression analysis, a statistical tool frequently used by economic researchers for analyzing large data sheets.

I decided to focus my survey on the three biggest collector markets: the USA, Germany and the UK.

Second, I conducted expert talks with fifty-one industry experts. This helped immensely in making sure that findings are widely commercially relevant and applicable in the art world and beyond. I spoke with commercial art mediators, including art gallery dealers, private art dealers, auction houses and ancillary art business providers, and with conceptual art mediators, including critics and museum staff. I spoke with collectors from every category—trade and private, serious collectors and occasional buyers, professional art dealers, investors, representatives from museums and foundations, and corporate collectors. I spoke with artists, with art market researchers and, finally, with experts from unrelated fields. After the expert talks, several international round-table discussions were held, bringing together partici-pants from each of the expert talk groups. These expert talks helped to generate a bigger picture of the art industry, as well as bringing a depth of creativity and diversity to the discussions. An investment banker, for example, has a completely different, yet enriching and unexpectedly comple-mentary view on the art market from that of a museum director. The talks were essential to verify results from the quantitative research, but it was this diversity that generated new ideas.

Third, I conducted case studies, to see if my hypothetical strategies stood up to practical application and to learn from best practice. I worked as a freelance consultant with three galleries (left anonymous to protect their privacy) in a longitudinal case study, ranging from as little as three months to a maximum of sixteen months, to help implement strategy and monitor success. Furthermore, I spoke to the founders or relevant staff of best-practice galleries, those that excelled in some area. Some of these have found their way into this book.

Fourth, numerous secondary sources were used to ensure that this book both delivers the latest findings on the art market and can guide the reader to other trusted sources.

To organize both the information I had gathered and my approach, I chose a business model framework from Professor Dr Thomas Bieger, President of the University of St. Gallen and, together with Professor Dr. Christoph Müller, supervisor of my PhD thesis on art galleries. The phrase 'business model' has already been used repeatedly in this book. Everyone has their own interpretation of it, particularly since every strategy talk, press conference or discussion between start-up founders uses this phrase. Even institutions from the public sector and non-profit organizations are using business model terminology to express their undertakings. A lot of definitions have been published over time, but Bieger defines a business model as the description of the way in which a company creates value on the market. This requires answers to the following questions:

VALUE PROPOSITION:
Which benefits do we transfer? What job has to be done?
CUSTOMER CONCEPT:
Which customers do we target?
COMMUNICATION CONCEPT:
How is this benefit communicatively anchored in the relevant market?
REVENUE CONCEPT:
How are the revenues generated?

GROWTH CONCEPT:

Which growth concept is pursued?

COMPETENCE CONFIGURATION:

Which core competencies are necessary?

ORGANIZATIONAL FORM:

What is the range of one's own company?

COOPERATION CONCEPT:

Which cooperation partners are selected?

COORDINATION CONCEPT:

Which coordination model is used?

The advantage of this model is that it offers an easy way to compare one business to another. To avoid getting too theoretical, let's take a look at the following example from the airline industry. As you will see, this concept is highly transferable to galleries and informs the remainder of this book.

BUSINESS MODELS
IN COMPARISON

	BRITISH AIRWAYS	RYANAIR
VALUE PROPOSITION	BA as part of global airline network	Selective offer
CUSTOMER CONCEPT	All customer groups and different classes (First, Economy)	Only one class
COMMUNICATION CONCEPT	Traditional communication along all channels	Very selective, focus only on price
REVENUE CONCEPT	Dynamic pricing model	Simple pricing model, extra charges for secondary business (baggage)
GROWTH CONCEPT	Buying competitors, partnership alliance with global networks	Step by step. Once one route is profitable, open the next
COMPETENCE CONFIGURATION	Network management, marketing	Cost management
ORGANIZATIONAL FORM	Focus on marketing	Simple leadership structure
COOPERATION CONCEPT	Large number of cooperation partners	No cooperation
COORDINATION CONCEPT	Extensive legal structure	Simple structure

Fig. 13

5

A New Business Model

With
so few gallerists
making
really good returns,
I wanted
to find out:
what are
the key factors
to success?
What do profitable
galleries
do differently?

Intrduction

I can start by stating two facts that I believe wholeheartedly.

MANAGEMENT IS NOTHING TO BE AFRAID OF

My heartfelt belief is that management in art galleries
should be neither feared nor reviled. Management has a
proven, positive impact on an art gallery's profit. Galleries
that believe in management, that have developed a functional
and rewarding business model that distinguishes them from
their competitors, and that regard it as a core competence,
simply generate higher profits than those that don't.

MOST GALLERIES DON'T MAKE ANY MONEY

According to my survey, 30% of galleries run at a loss, and
55% make less than $200,000 a year. The average profit
margin is 6.5% of revenue. These results turn the constant
media hype on its head, and they are particularly striking for
an industry that has historically made a virtue of veiling its
exact figures.

So what are the success factors for those galleries that are
thriving? I set out to test the correlation that I believed
existed between profitable galleries and effective business
management models, both from an academic and a practical
perspective. I questioned more than 8000 art galleries and
spoke to more than fifty art market experts. I then put my
findings to the test in three case studies.

 This book is all about making galleries successful. I believe
that the galleries that can locate their business model in the
context of the nine trends below will blaze a trail towards a
new gallery model and a more profitable market segment.

(1)

Most galleries offer a very similar value proposition, and clients are flooded with offerings. Art galleries must not only establish a value proposition that allows them to differentiate themselves from other players in the market, but also sell the advantages of that value proposition to potential clients.

(2)

Galleries do not even try to target the best customers any more—they all just fight over the same people. A more progressive approach would be to bring in a new group. They are young, highly educated individuals with a huge income. Barely familiar with the arts and with no track record in the art market, they may be willing to buy pieces of art on the basis of four motivations: social, symbolic, cultural and emotional. This group both seeks 'edutainment' and sees art buying as a means of admittance to a certain social class. In order to satisfy this new customer group, the gallery must succeed in offering them a convincing value proposition.

(3)

Galleries all employ the same well-worn marketing tools, and their current communication concept simply does not reach their customers any more. It is all about building a brand. Brands will help galleries to navigate the market and present unique characteristics. A gallery must therefore build up a strong brand that is instantly recognizable to existing and potential customers alike, and which distinguishes the gallery from its competitors.

(4)

Galleries' revenue concepts do not vary much, and the current concept has gathered dust for decades. Consequently, revenue, and profits, are extremely low. Attractive and innovative pricing models must therefore be introduced,

and side products should be commercialized while keeping
costs low.

Galleries must define a suitable growth concept. The
market is highly fragmented, with hundreds of players in
every city, all with very similar value propositions. Even the
products are interchangeable, as artists become harder to
distinguish from each other. As gallerists increasingly
accept the results of professionalism, the industry will see
the emergence and growth of more global players with the
type of international art hub presence currently seen in only
very few examples, such as Gagosian or Hauser & Wirth.

Competencies will play a much larger role as the adoption of
strong management principles raises professionalism
within the industry. This development will be accompanied
by a shift in the minimum education requirements and
general caliber of candidate for a job in the industry, along
with a commensurate shift in the salary that such a role will
attract. Employees must display both management
know-how and a solid business ethic.

Private deals are generating more revenue than ever
before. Auction houses are becoming more involved in the
primary market through new ventures such as Sotheby's
S|2, giving artists an avenue for direct sales without the
intervention of a gallerist, and even museums are buying in
artists straight from art school. The traditional distinction
between the primary and secondary market is becoming
blurred. The increasing complexity of this new market,
combined with increased demands by clients for profes-
sionalism, calls for a clear organizational structure.
Gallerists should take this as an opportunity to extend
their areas of expertise and immerse themselves in all the

career steps of an artist's life-cycle. In order to achieve this, galleries must define clear roles, job positions and descriptions, adopting technology where necessary to foster this process and speed up business processes.

(8)

Currently, art galleries have very few network partners. In order to gain access to new customers, galleries must engage in cooperation with a range of partners. The selection of and engagement with partners will play a significant role in developing the market and its potential.

(9)

Coordination is strongly linked with the professionalization of industry practices. Artists have become more demanding, and galleries can no longer exhibit only in the local gallery space but must show internationally at fairs or in partner galleries. This requires detailed cooperation concepts, including contracts. Nor is the relationship between artists and galleries excluded from a health check; these relationships, too, should be subject to review, whether formal or informal.

The following pages describe a revised business model for running an art gallery, and the table opposite compares existing business models with the new business model. It references a market segmentation by customer that is described in the pages that follow.

TRADITIONAL ART GALLERY BUSINESS MODEL
VS. NEW ART GALLERY BUSINESS MODEL

	TRADITIONAL MODEL	NEW MODEL
VALUE PROPOSITION	Sale of works of art	Offering a full range of services
CUSTOMER CONCEPT	1. Art lover 2. Corporate collector 3. Dealer/collector	Market segmentation in three groups (Arty, Rookie, Traditional)
COMMUNICATION CONCEPT	Traditional channels (use of postal mailings, advertisements)	Establish a brand
REVENUE CONCEPT	Sale of works of art	Attractive pricing models, keeping costs low
GROWTH CONCEPT	No growth concept	Distribution on a global level
COMPETENCE CONFIGURATION	Competence in art history	Management, marketing and sales
ORGANIZATIONAL FORM	Focus on primary market; gallery with gallery director plus assistants	Three-pillar structure (Garage, Gallery, Fine Art)
COOPERATION CONCEPT	Artists and other galleries	Art and non-art institutions to establish long-term relationships
COORDINATION CONCEPT	No contracts in primary market, unclear processes in secondary market	Contracts with all partners, ongoing revision of these relations

Fig. 14

Goals of Art Galleries

A wholesale revision of any business model needs to iden-
tify clear goals at the outset. The goals of an art gallery can
be divided into three highly interdependent categories:
economic, artistic and socio/ethical.

Historically among galleries, all the attention was trained
on the artistic merit of the exhibitions, and the profit im-
perative—the most efficient use of resources to maximize
return—was lost to an overriding creative preoccupation.
Consequently, a tradition has evolved of amateur management
presiding over an enterprise that is all too often sinking into
financial obscurity. If galleries want to sustain and improve
their businesses, they have to follow the example of other busi-
nesses and start to integrate profit orientation into their goal

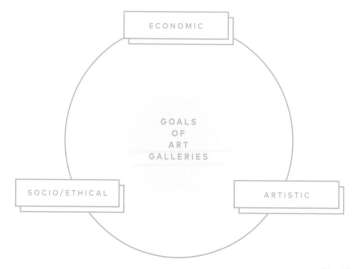

GOALS OF ART GALLERIES

ECONOMIC

GOALS
OF
ART
GALLERIES

SOCIO/ETHICAL

ARTISTIC

Fig. 15

horizon. Their product may have a perceived cachet, but bills and artists must be paid, and fostering the development of a gallery costs money.

The importance of money notwithstanding, a gallery will be equally short-lived if it neglects the traditional goals of an art gallery. While they are free of the political aspects that a museum must consider, a commercial gallery must also meet the goals by which it will be judged: those of artistic value creation and meeting a socio/ethical need.

If galleries want to sustain their businesses, they have to integrate profit orientation into their goal horizon.

The artistic goal is to create effective artistic value within the gallery. This demands that the gallery's artistic standard gets the approval of its reference group. Such a subjective standard inevitably produces an opaque and shifting valuation system that is highly susceptible to manipulation. If the art community does not endorse the gallery's exhibitions and programme, credibility is lost, and any attempt to meet economic goals is undermined. Damien Hirst, who is a living example of successful commercial and artistic balance, illustrates a similar point from the artist's perspective. Frequently seen as merely fashionable, he ensures that his artistic credibility is maintained with exhibitions at major museums around the world—even contributing $440,000 out of his own pocket towards show redecoration costs at London's Wallace Collection in 2009.

The final goal of an art gallery can be described as socio/ethical. Galleries are part of an industry that runs on trust and personal interaction—with artists, customers and colleagues. Such lack of formality creates what might seem, to outsiders, to be a worrying lack of oversight that leaves the door open to price engineering or other forms of covert agreement. It is very rare for gallerists to hold written contracts either with artists or with business partners, and insider trading is widely accepted as part of the business. That said, if galleries want to stay in business, they must

conduct themselves according to the accepted ethical norms of the industry. To earn credibility, not only among colleagues but also among buyers and artists, gallerists must act ethically and responsibly.

These three goals are the cornerstones of a successful art gallery in the twenty-first century. We could therefore repeat our formulation of the definition of a successful gallery:

An art gallery is successful when it manages to gain the approval of its reference group, while at the same time maximizing its financial profit on the basis of business practices that follow ethical guidelines.

Organizational Concept

An organizational concept offers a good starting point for a revision of current gallery business models, and galleries can be conceptually organized into streams that align with the career steps of an artist's life cycle. Artists' careers can be mapped onto three key phases: the shopping phase, the decision phase and the final phase.

PROGRESS OF AN ARTIST FROM ART
SCHOOL TO STARDOM

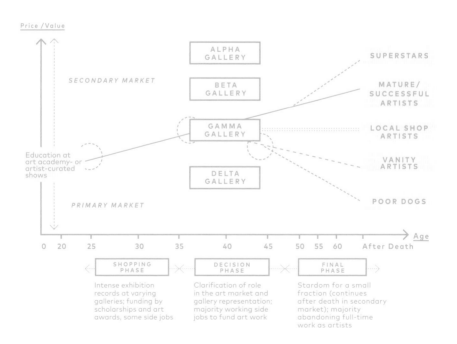

Fig. 16

The *shopping phase* is characterized by young artists with impressive exhibition records at varying locations, particularly off-space, who are funded by scholarships and hope to be spotted by an alpha or beta gallery.

The second phase, the *decision phase*, is characterized by more mature artists, those who enjoy success and popularity, who are becoming identifiable, who have found their role in the art market and who may or may not have representation.

The three career chapters can be reflected by a three-tier trading structure: the garage, the gallery and fine art.

The *final phase* sees the departure of the vast majority of artists, who abandon full-time work as artists and follow other pursuits. The work of a small fraction of artists is successful and is traded on the secondary market, both during their creators' lifetimes and after their deaths.

These three career chapters can be reflected by gallerists in a three-tier trading structure: the 'garage', the 'gallery' and 'fine art'.

During the *shopping phase*, the garage presents an exhibition space for upcoming and emerging artists. Its aim is to create a dialogue between the local off-space scene and upcoming artists, and to establish the brand of the gallery within the art community and among potential buyers, existing buyers and conceptual art mediators. It follows the non-profit model of a Kunsthalle, selling works on behalf of artists but reserving the gallery's share of the money for a central fund that is used solely to sponsor two to four exhibitions annually and to cover the running costs of the premises. Community spirit and the desire to see exhibiting success among the artist group tend to be powerful forces in the garage phase. The garage is also supported by a small circle of benefactors, which includes the gallery owner. Benefactors are obliged to invest a relatively small annual amount in the garage, free of any conditions but on the understanding that they are supporting upcoming and emerging artists and have access to the off-space art scene.

The administrative expenses for this circle need to be minimal, and tightly controlled. Benefactors and artists receive an annual report that includes a statement of income and reports on past and upcoming exhibitions. The garage is run and organized by one part-time employee, preferably a young student with aspirations to become an art gallerist and who is connected to the art scene.

Overall, the garage represents the perfect tool for the gallery to establish a brand not only on the scene but also with potential buyers. It gives the gallery great credibility, has enormous potential and is broadly self-supporting economically. Interestingly, in April 2016 New York's power-house gallery Greene Naftali opened a new temporary space in Brooklyn. In their press release they stated that this new space is 'offering an alternative to conventional viewing conditions, as well as expanded working parameters in which artists may realize a wide range of projects. The flexible venue will be home to dynamic, open and spontaneous programming'. Coincidently, the space is called Garage.

The gallery is the showcase for artists in their *decision phase*, and it is the part of the model that most closely resembles traditional art gallery practice for contemporary art. In the new model, however, the gallery will drastically limit exclusively held artists. An average gallery—one owner with one employee—simply cannot exclusively represent between eight and twelve artists worldwide. Gallerists will need to focus on the pick of the artists and access global representation by partnering with other galleries or opening new locations internationally. A reasonable number of artists for an average-sized gallery to represent, and for whom they also act as agent, is between one and four. An alternative approach may be to keep a larger number but show them only nationally. However, this exposes the gallery to poaching raids by more well-known international galleries.

The garage presents an exhibition space for upcoming and emerging artists.

In general, galleries need to develop a strong brand and a clear profile. Offering solely contemporary art will no longer be an option for any gallerist hoping to be successful. They should certainly incorporate added services, but also create the clarity and structure that is provided by the garage/gallery/fine art organizational concept. Cost-effectiveness needs to be at the forefront of every new strategy, and collaboration with partners from other industries is one of the most practical ways at a gallerist's disposal to strengthen the brand and reach out to new customers. Furthermore, galleries should move to cheaper locations or rent temporary spaces from where they invite targeted customers to visit.

The Gallery is the showcase for artists in their decision phase.

Fine art is the third and final part of the organizational concept. Working with the output from the *final phase* of an artist's life cycle, it describes the typical activity of a gallery involved in the secondary market. Fine art works are those from artists that the gallery built up, now so successful that they attract considerable resale value, and artists from other categories, such as modern or post-war art who are traded on the secondary market. One of the revelations from my survey was that galleries operating in the secondary market usually make higher profits. Every gallery should therefore strive to be involved in this area, building good contacts not only with the right colleagues and dealers but also with the wealthy clients that can afford the higher prices.

Contrary to belief, fine art does not need any fixed location. When it comes to showing a work, showrooms at art shipping companies or a conference room in a hotel are as good as London's Bond Street.

There are two advantages to this three-fold organizational structure.

First, a foothold in all three stages of professional development generates higher and more diversified revenue and more sustainable profits, clearly illustrated by the difference in the three profit streams. Galleries whose artists are in

the shopping phase, whether in the off-space garage or not, do not make much profit. The overheads of establishing the artist in the market are heavy, with advertising and catalogue costs having to come out of a relatively slim sale price. Galleries representing artists in the decision phase face heavy competition from other galleries and market fluctuations. The real profit is found among the galleries that do at least some business in the final phase of the life cycle. These usually generate high returns because they are in a far more powerful selling position and make higher margins from the secondary market. A presence in all three markets insulates against troughs in any of these. Star gallery owner Iwan Wirth explains this in an interview with

ART GALLERY
ORGANIZATIONAL LAYOUT

GARAGE	GALLERY	FINE ART
· Primary market, shopping phase · Temporary location for upcoming artists · Circle of benefactors	· Primary market, decision phase · Small number of artists · Strong profit orientation · Clear profile and brand	· Secondary market, final phase · Trading and dealing in secondary market · No location needed
Director of Garage	Director of Gallery	CEO or Director of Fine Art
· Under thirty, connected to scene · Plans 2–4 shows per year · Solely responsible · Communicates via blog · Partners are academies, magazines, critics · Low salary	· Experienced marketer, entrepreneurial mindset · Plans all exhibitions · Solely responsible · Communicates via tools · Partners are from the luxury industry, strategic partners, etc. · Base salary plus bonus	· Knowledge of management · Solely responsible · Focused communication · Partners are colleagues, dealers and investment firms · Salary based on revenue

Fig. 17

legendary art market reporter Georgina Adam in the *Financial Times* in 2010. 'It is a balance, but operating on the secondary market makes very long-term investments in the careers of certain artists possible. The cycles are far more extreme if you just do primary.'

The second advantage of the three-fold structure is that galleries are free to be more flexible, ramping up or moderating activities over time as the market dictates and even using temporarily rented locations where appropriate. Gallerists must think of their role as an orchestrator who organizes and manages activities in a network, outsourcing to a wide pool of service providers in tightly controlled relationships with detailed and restrictive contracts.

Case Study

GALERIE EIGEN+ART

Galerie Eigen+Art, the German powerhouse gallery known for representing Neo Rauch, is a good example of a gallery that practices the three-pillar structure. Gerd Harry Lybke, known to the entire trade as Judy, started the gallery in 1983 in Leipzig, in the former East Germany. In 1992, he opened in Berlin in premises on Auguststrasse, the street synonymous with Berlin's gallery and museum district. Today, the gallery has twenty-two full-time and four freelance employees.

Judy is a German art dealer of legend. Stories about him are reported in every major journal. He has never lost his heavy East German accent, and he moves straight to a direct and reassuring informality with everyone with whom he deals. I first met him in 2004 at a fair and have since regularly run into him. In Berlin, we had neighbouring offices. The story of how he became a gallery owner is entertaining. Originally he fell into the art scene when he took on male modelling work for young art students in Leipzig for cash. He began to represent the better students from his small rooms in Leipzig; this soon evolved into what the international art world now recognizes as the Neue Leipziger Schule (New Leipzig School), the most prominent artist of which is Neo Rauch.

Eigen+Art's three pillars (garage, gallery, fine art) are in separate premises. The gallery is in Eigen+Art's ground-level space on Auguststrasse, in close proximity to museums and other leading galleries. When you walk in, you are greeted by two or three friendly gallery employees. The room devoted to the Gallery is surprisingly small, but the ceilings are high, giving

a sense of spaciousness. A slim staircase to the right, behind a chain barrier with a discreet 'Private' sign, leads to the upper floor. This is where the fine art is to be found. Judy or one of the directors occupies a huge desk in one of the four rooms that show works mostly from the gallery's artists.

The garage is a recent addition. In 2012, Judy opened the Eigen+Art Lab in Berlin in Alte Jüdische Mädchenschule, a stone's throw from the gallery. In January 2015, the garage moved to premises in Torstrasse, again just a few minutes away from the gallery space. Here, around five exhibitions are organized every year. 'It's an exhibition place for artists who have no exhibition history in Germany, or virtually none', explains Judy. Artists shown in the Lab are strictly non-gallery artists. It uses all the resources of the mother gallery (marketing, contacts, legal assistance), but is to all intents and purposes a separate exhibition space from the gallery.

Probably foremost among the many benefits of running the Lab is the opportunity it offers for testing out new artists: a kind of arts laboratory, if you like. The gallery closely monitors collector and public reactions to the artists. If the signs are good, the artist's chances of getting another exhibition are quite high, with the possibility of conversion into the regular gallery programme. Secondly, both gallery and artist can get a feeling for each other and decide if they really want to work together. Since there is no commitment, it is easy to separate after a show if the partnership was not right for both sides. Thirdly— and Judy highlighted this when we talked—the Lab is an experimental place for the gallery staff. 'All my gallery employees have some artists they favour, but they can't work with them because I already have my set of artists. This gives them the chance to treat the space as their own.' The Eigen+Art Lab is run by two former employees who cut their teeth in the mother gallery over several years. Finally, since Eigen+Art's artists are well established and hence costly, the Lab offers the unique opportunity to show less expensive artists and capture a whole

new customer group—younger and less experienced in the art market but nevertheless the collectors of the future, who can be nurtured and turned into lasting clients.

From an economic viewpoint, the Lab produces financial dividends. The combination of a dedicated team, low-cost structure and support from the mother gallery has produced an independently profitable enterprise in its own right.

The Lab, the gallery, and the upper floor combine to give Eigen+Art a position in all three phases of an artist's life cycle. Not only is this highly revenue generative, but it creates a natural customer base for Galerie Eigen+Art among those who are drawn to its value proposition. Draw these threads together with the excellent customer service, led by Judy, and these are the success factors of Eigen+Art.

ADVICE FROM JUDY LYBKE

Start with small rooms. The opening night is then crowded, even if only friends and relatives show up.

Find great artists who really fit you. A gallery is only as good as the artists it represents.

Case Study

JAMES FUENTES GALLERY

James Fuentes also applies a three-tier organizational structure. A native New Yorker, James grew up on the Lower East Side, making it a natural decision to open a gallery in this neighbourhood in 2007. Today, he runs his gallery with three full-time employees. The last two years have established James as one of the stars of the New York gallery scene. He more than doubled his gallery by acquiring the neighbouring space in December 2014, reaching a total of 170 sq. m (1,830 sq. ft) from an initial 74 sq. m (800 sq. ft). He also expanded his organi-zation from no staff to three full-time employees. In 2015 he marked his first participation at Art Basel in Switzerland, establishing himself in the face of fierce competition among New York's upcoming and emerging galleries. Without a doubt, James is one to watch.

When I first walked into this gallery, after fighting through rush hour on busy Delancey Street on my Vespa, the one big space caught my eye. The I walked around and found James in a room behind the larger gallery space, separated from the rest not by a door but by the clever placement of a wall. The second room was much smaller, making up less than a quarter of the gallery space. It is a small room, but vital to James's setup. 'Welcome to Allen & Eldridge', he grinned, and we immediately had our topic. Allen & Eldridge, named after the two streets that frame the gallery, is James's garage or, as he calls it, his 'project space'. He treats it like a separate entity, with its own website, its own rules and its own program. In his words, 'In baseball, all good teams have a farm league. This is where the talents play. Allen & Eldridge is just that: an experimental space for new

voices.' The advantages are obvious. For younger artists, James can use this smaller room to show their works in a more intimate setting. 'Young artists like this because the large room might come too soon for some.' In addition, it is a playground for his employees. Like Eigen+Art, one of his directors is involved in the Allen & Eldridge program. Of the ten shows James did in 2015, 50% were with artists introduced to him by this director, giving the director valuable experience in organizing a full show as well as keeping him motivated and engaged.

James also highlights the flexibility that space and staff have given him. 'We don't plan a year in advance for these shows. We see someone interesting and can mount the exhibition within weeks.' For James, it is reminiscent of the days when he started his first gallery, an enterprise the same size as Allen & Eldridge that he opened in 2007 in Chinatown, in lower Manhattan. Another advantage of this space is that he can stay in touch with the emerging young art scene and ensure that events are shaped to reflect its character. Only at Allen & Eldridge openings does he offer beer—far more in tune with the predominantly young opening crowd. The youth of this crowd, however, is reflected in their spending power, and Allen & Eldridge does not pay its way financially. Without the backing of the James Fuentes Gallery, it would have to close down.

To complete the three-tier organizational structure, James is also active in the secondary market and will need to increase space to accommodate this. Again, rather than renting a new space, he will refurbish, moving Allen & Eldridge into the basement and using that space as a viewing room for secondary works. 'I'm trying to get my feet wet in the secondary market. It's something that takes time.' With the experience he has already on his side, I am betting he will cope. Before opening his own gallery, James worked with Gavin Brown and Jeffrey Deitch—formidable mentors for learning to deal.

ADVICE FROM JAMES FUENTES

Learn about real estate. Second to the programme, real estate is the most important central element that contributes to the sustainability of a gallery, especially in a major city.

Develop a strong connection with your fellow gallerists.

Value **5.4** Proposition

Most galleries that I observed offer their clients a very similar value proposition. According to leading researchers, however, it is the value proposition that distinguishes a firm from its competitors. Furthermore, they argue that companies must enrich their businesses and develop them into an integrated value chain, as my organizational structure illustrates. Most art galleries see contemporary art as their basic product, but they neglect to look at the demands and wishes of customers to add value and increase their value perception. My structure defines a three-part role for the gallery across all markets, thus opening the door to an innovative and extended value proposition.

Marketing guru Philip Kotler identifies five ways in which customers perceive products, adapted below for art galleries.

(1)

The most fundamental level is the core benefit. It symbolizes the benefit that any customer will get out of the product. In our case, the core benefit is the presentation of the work of art and its perception as a source of inspiration, decoration, discussion or investment.

(2)

The second level is the basic, generic product: the rudimentary thing that is the substance of the value transfer between gallery and customer, in this case the actual work.

(3)

The expected product represents the customer's minimal expectation. Of course, these expectations vary by customer. In an art gallery, the most common expectations, given the primarily social motivations of most people who step through

the door, are food and drink, socializing, an innovative and diverse program curated by the gallery, excellent service and quality art.

The augmented product is a means of product differen-tiation; customers are offered more than they think they might need or expect. This creates a customer reliance on the gallery. A revised three-fold structure would offer the customer a role in the art scene throughout the life cycle of an artist in every market, a warm welcome, a trusted brand, bringing the benefits of transparency and limited complexity, an event, 'edutainment', and access to a new network.

The potential product represents future expectation, or everything that a customer might feasibly get in the future. This might include peer group reputation through participa-ting at an event in this gallery, access to a particular social or business peer group, inclusion in the gallery program, invitations to VIP events, or expectation of an increase in the value of a piece post purchase.

A NEW BUSINESS MODEL

Case Study

SKARSTEDT GALLERY

Skarstedt Gallery was founded in 1994 by Per Skarstedt, and today it operates from three locations—two in New York and one in London. The gallery specializes in historically researched exhibitions of modern and contemporary European and American artists. The gallery works with and exhibits artists from the international elite: Francis Bacon, Georg Baselitz, George Condo, Yves Klein, Richard Prince, David Salle, Christopher Wool and many others.

Skarstedt Gallery's business model sets this modest and friendly gentleman apart from most other dealers. 'I run my gallery in the old-fashioned way', starts Per when I met him during a holiday in Bavaria, Germany. In practice, it is not really as old-fashioned as all that. He has managed to combine the traditional gallery model with a new model that leads to a hybrid structure. First, Per acts as a dealer. 'I managed to build up an inventory, and every now and then I sell pieces from it. Sometimes I keep works for over ten years.' Secondly, unlike any other dealer, he regularly organizes exhibitions in his three galleries and actively works with his artists. Thirdly—and this is what really sets him apart from a dealer—he shows lesser-known artists, combining the primary and secondary markets. 'Richard Prince came to me and introduced me to Justin Adin, an upcoming American artist born in 1976. I liked him, and we did a show in October 2014 that I really enjoyed.'

To grasp the complexity of Per's business model, I asked how he built his business up from the start. 'I spent most of my time in the late eighties and early nineties in Cologne, Germany, to get in touch with the local art scene.' The first pillar of his business model took shape through his initial trading. The business logic was simple. 'When I bought three works, I sold two and kept one.' This made

enough for him to live on, buy new works and slowly build an inventory. In 1994, he opened a New York gallery space, at that time a tiny 100 sq. m (1,080 sq. ft). Despite the cramped quarters, he set up two office rooms for the secondary activities and a small exhibition space for the primary.

Per's business model offers a surprisingly uncommon value proposition to his clients. The core and basic benefit has been adopted by very few dealers: he carries a broad, high-quality inventory of works that are in high demand and short supply. Because he is firmly established in both markets, Per offers his clients young artists as a future investment; established artists as a safe investment; and hugely desirable works as a pure purchase of passion or to complete a collection. Since most works are expensive, customers expect the 'Christie's experience', and Per's impeccable service includes every aspect of professional art dealing, from authentication certificates and condition reports to warehouse facilities and shipping. Per also highlights the relevance of his team: 'My people are amazing.' As well as offering a premium service, Skarstedt feels reassuringly open with its clients—particularly regarding prices—and this has kept many of Per's first buyers from the early nineties loyal to him. Buying at Skarstedt is an experience in itself and gives you access to an exclusive world. His galleries are in the best locations (London's Old Bond Street and New York's Chelsea and Upper East Side), and he is a charming and sociable host, regularly organizing dinners and inviting collectors to studio visits or the world's top art fairs.

Per's formula for success is both simple and clear. 'It's experience, and being active in the market for so long. Experience helps you to select the right artists and their best works.'

ADVICE FROM PER SKARSTEDT

Start small, and keep your overheads very low.

Be cautious about copying my model too precisely in today's market. The art market moves faster today.

Case Study

CLEARING

CLEARING was founded in 2011 by French retired artist Olivier Babin. Today it operates out of Brooklyn and Brussels. Its program incorporates young European and American artists with names such as Harold Ancart, Korakrit Arunanondchai, Marina Pinsky, Calvin Marcus and Sebastian Black.

CLEARING's success has much to do with a lack of cynicism, almost a naivety in its value proposition—a proposition that Olivier conveys with fervour when I meet him in his gallery in New York. 'We try to do things differently. For us it's the artists who count. We won't compromise on our decision to show only the best and newest emerging artists. And we truly believe in what we are doing.'

Many young and upcoming galleries claim to have a similar value proposition. CLEARING's philosophy, however, can be seen at every turn. First, their location has credibility to spare. Avoiding fancy Chelsea or Soho, Babin chose the off-location Bushwick, Brooklyn. In a former truck repair depot, he hosts a 460-sq. m (5000-sq. ft) gallery, roughly five times larger than the upper-floor location they occupied until October 2014. The large, clean space is indistinguishable from the interior of a Chelsea gallery. The outside area, however, symbolizes the spirit of the gallery. It is a complete and welcome contrast to upscale Manhattan.

Olivier has also shown considerable individual flair with his selection of artists. His new partner, art historian Harry Scrymgeour, worked for many years for Michael Werner in

London and VeneKlasen/Werner in Berlin. Both are highly intel-
lectual, communicative and well connected, yet both wear their
social connections lightly. It is their passionate connection to
the art scene that gives them access to standouts from elite
M.F.A. programs and other young stars. It also brings authen-
ticity to their representation of their artists.

Being close to the artist and distancing themselves from the
market is also symbolized by their marketing effort and selection
of partners. Harry: 'We only run a website and a Facebook page.
That's it. We don't believe in marketing much.' Despite the
low-level approach, their openings attract huge crowds. Those
that come are mainly from the art scene, mostly art students
and art devotees. It is certainly different to the crowd in
Chelsea's galleries and feels a lot closer to the heart of the art
scene. And not everyone can buy from CLEARING. 'We carefully
select whom we sell to. We don't have to sell to everyone',
states Olivier firmly.

CLEARING's value proposition is the gallery's sharp eye for the
most exciting upcoming artists, as well as its consistent program
and general sense of integrity, and it has attracted collectors in
droves. It has earned the gallery a spot at many acclaimed art
fairs, including The Armory Show, NADA and Paris's FIAC.

ADVICE FROM OLIVIER BABIN

A general rule of action: do not compete. Do your own thing.
What other people are doing, you will not do better and most
probably not even as well.

As a gallerist, the artist and the work must remain the center
of your universe.

**COMPARISON OF THE VALUE
PROPOSITION OF TWO GALLERIES**

	SKARSTEDT GALLERY	CLEARING GALLERY
CORE PRODUCT	World-class artists	Emerging artists
BASIC PRODUCT	Best works of art in high-quality exhibitions	Most upcoming and cutting-edge artists
EXPECTED PRODUCT	'Christie's experience'	'Truck repair experience'
AUGMENTED PRODUCT	Transparency, buying from a brand	Access to the art scene, off the beaten track, at the pulse of the scene
POTENTIAL PRODUCT	Access to an exclusive circle, dinners, studio visits	Participating in the rise of the next superstar

Fig. 18

Customer Concept

I realized from my research that most galleries target a similar group of customers. Consequently, competition for existing customers is fierce. A successful gallery will, therefore, identify new customers and target them—in addition to existing customer groups—with a corresponding value proposition. This also means that a gallery may need to discard some customer groups that competitors regard as relevant; however, a disciplined and single-minded focus on the most relevant customer groups will allow art galleries to provide greatest value to their clients.

Practitioners often claim that the demand side of the art market is saturated. However, a look at any published figures reveals that the general wealth increase over the past years has remained very steady. The 2015 *Global Wealth Report* shows that the number of millionaire households rose by about 6.6% in 2014, to 14.6 million. The USA had by far the most millionaire households (4.4 million), followed by Japan (2.5 million), France and Germany. High net worth individuals invest on average 10% of their wealth in so-called investments of passion. All of this points to further demand that galleries can exploit.

In emerging economies such as Brazil, India or China, a whole new class of collector is developing alongside the increasing personal wealth. China (including Hong Kong) ranks as the third largest art market, owning a 19% market share, closely headed by the UK with a 21% global market share. With the exception of a brief reversal in 2011, when China caught up with the USA and took over the leading position, the USA has yet to be seriously dislodged as the world number one, with a 43% market share, according to the *TEFAF Art Market Report*.

All of this points to further demand that galleries can exploit.

When my business partner Christoph Noe and I put together *Larry's List Art Collector Report*, the only report on the global art collector scene, we got similar findings. A quarter of all collectors are based in the USA. Other countries have only a fraction of the US numbers: Germany, following the USA in rank terms, has 8% of the world's collectors, closely followed by the UK, Brazil and China. More than half of the entire collector base is located in the top five countries. The number of collectors in developing countries is increasing rapidly. Collectors from China, India, and Brazil already account for 15% of global collectors.

New York is the undisputed leader of the collector cities, with more collectors than the whole of Germany or the whole of the UK. The only city to even approach New York's supremacy is London, which, combined with New York, accounts for 15% of the world's art collectors. São Paulo and Los Angeles each have 3% of the market by collector.

The *Larry's List* report also states that the average age of a Contemporary Art collector is fifty-nine. A global break-down by age shows that an overwhelming 90% of art collectors are over forty years old. Male collectors are in a 71% majority. Most collectors work in the financial services sector (12%), closely followed by media and entertainment (11%). The consumer products sector, the non-profit segment, and health care make up the top five business sectors of art collectors.

These are the existing collectors. But who are the new guys? They could be male or female, and can be described as well-educated (university graduate), earning a relatively high income, and in white-collar employment. As identified above, and as research suggests, their motives to visit an art gallery could be twofold.

First, an art gallery visit satisfies needs that are not directly related to the arts. These are *symbolic* and *social*

Collectors from China, India, and Brazil already account for 15% of global collectors.

needs. It allows them to communicate their personality and value. Like Tod's shoes, a Rolex Daytona (with a black dial), or an Hermès Kelly bag, they achieve the same effect as being seen at a certain event to demonstrate their association with a particular group. In addition, communication with others and meeting peers are satisfied by an art gallery visit.

I would argue that the symbolic and social motives are prevalent: the primary motive to visit an art institution is the social activity.

Second, an art gallery visit, like a museum, could also stimulate needs that are related to the works of art. These can be *emotional* and *cultural* needs. People can and do visit art galleries simply to let art help them resolve a problem, to inspire them, to escape from daily problems, or to fulfil a constant need to learn.

Given that it is the two spectator groups, the Art Enthusiasts and the Opening Crowd, that comprise the biggest visitor numbers at galleries, I would argue that the symbolic and social motives are prevalent: the primary motive to visit an art institution is the social activity.

This description is supported by a study on audience motivation, choice, and relationships with cultural products and services written by Pulh, Marteaux & Mencarelli in 2008. The authors argue that there are seven broad consumer trends: (1) consumers seek a shared rather than an individual experience; (2) their senses need to be stimulated in a number of ways; (3) they wish to get involved and become a 'spect-actor'; (4) they want 'edutainment', combining acquisition of knowledge with an emotional response; (5) they wish to choose, in accordance with their wants and needs, a mix of genres, giving precedence to one or the other; (6) they want it all and want it now; and (7) they want to integrate new technologies in the consumption.

Why don't gallery visitors come in greater numbers? A key reason is that galleries effectively deter young visitors by making them feel that they do not belong. In particular,

bankers, consultants, attorneys, and corporate employees do not participate in the market, partly as a consequence of insufficient funds but mostly from uncertainty and lack of familiarity with the market. Top collectors from the banking world, such as Steven Cohen or Leon Black, may buy, but their middle management has not necessarily followed suit.

There are four risks that deter people from entering a gallery and buying art. First, there is a *functional* risk. People fear that when they visit a gallery, they may be bored and hence waste their time and money. Second, being seen somewhere that doesn't match our own perception of how others see us can be described as *social* risk. Third, the *psychological* risk describes the insecurity that may be felt upon entering a gallery if the visitor lacks knowledge and experience. Finally, there is an *economic* risk associated with money and leisure time that is at stake (which clearly overlaps with the functional risk).

I can see this behaviour pattern clearly among my peer group from business school. Working in private equity funds and in the investment banking divisions of leading banks, they earn a considerable salary. It is now pretty much an annual event for each of them to ask me if I can recommend a piece of art that looks good but also has investment potential, and the outcome is always the same: I give them names of galleries they should visit, and they rarely follow through because of the risks described above.

London-based Iranian collector Kamiar Maleki has recently started to actively build up an art collection.

That said, a few have taken the plunge and are starting to become serious art collectors. Two are even, highly unusually, under the age of forty at the time of writing. London-based Iranian collector Kamiar Maleki has recently started to actively build up an art collection, while New York-based Rodney Reid acquires contemporary photography. Working in private equity and previously an executive director at UBS, Reid is a founding member of The Contemporaries, a collecting group formed by Harvard Business alumni.

The following table summarizes the characteristics of the new customer group that galleries must target, and identifies what distracts them from entering.

DESCRIPTION OF
A NEW CLASS OF CLIENT

DESCRIPTION	WHAT DISTRACTS THEM
DEMOGRAPHIC: · 28+ GEOGRAPHIC: · International travellers ECONOMIC AND SOCIAL STATUS: · Highly educated, high income PURCHASE BEHAVIOUR: · Symbolic needs: demonstrate association with a group · Social needs: communication and exchange with others · Emotional needs: consume art as inspiration · Cultural needs: acquisition of knowledge and education PERSONALITY AND LIFESTYLE: · Stimulation of senses through quality art · Involvement ("spect-actor") in fun events · "Edutainment" with excellent crowd · Integration of technology THEIR RELATION TO ART: · Irregular attendance at openings · Little experience of the art market · Enjoy the event more than the art	OTHER LEISURE OPTIONS AVAILABLE: · Sports · Bars, restaurants, clubs RISKS: · Functional risk: fear of wasting time and money · Social risk: being seen in a place that does not match the perception they want to project · Psychological risk: feeling insecure, uncomfortable, intimidated by entering unfamiliar world · Economic risk: money invested falsely

Fig. 19

This new customer group, as with any other customer group, needs to be targeted with a tailored value proposition— something that is more easily achievable under my threefold structure than within a less well-defined organization. In order to simplify things, I have clustered existing customer groups into three target groups. This table includes both buyers and people who are unlikely to buy something in the near future but who spread valuable word of mouth publicity.

(1)

First, there are those who have close ties with the art community: the Arty group. This is numerically huge, but usually lacks the funds to buy. It consists of art students and conceptual art mediators.

(2)

Second, there are those with only a loose connection to the arts but with funds. So far, they have been completely left out of the market. This group is numerically the biggest group and has the greatest potential. Attracting these people from outside the market to within and winning them as clients should be the new aim of gallerists. It is precisely this group to which I direct the most attention. As it combines both the new group of potential customers with an existing customer group of art connoisseurs who have yet to be tempted into wider purchasing patterns, I will christen them the Rookie group.

(3)

Third, there is the group of people who have long been actively involved in the arts. They are the buyers that most galleries compete over; they are what most people think of when they think of an 'art buyer'. Their impact on the market is proportionally huge compared to their actual number. Given their long history and close connections with the art market, I will call it the Traditional group. It includes Art Lovers, Dealers/Professionals, Investors/Speculators, Museums/Foundations, and Corporate Collectors.

The following table summarizes the target groups, their description, and how the value proposition fits into it.

MARKET SEGMENTATION AND
CORRESPONDING VALUE PROPOSITION

DESCRIPTION	VALUE PROPOSITION
DEMOGRAPHIC: · 28+ **GEOGRAPHIC:** · International travellers **ECONOMIC STATUS:** · Highly educated, high income **PURCHASE BEHAVIOUR:** · Little or no purchase record **PERSONALITY AND LIFESTYLE:** · Motive: decoration, inspiration, social status · Enjoy the event more than the art	**GARAGE:** · Insight into emerging art scene · Contrast to usual bar program before/after dinner · Enjoy easy and unconventional first access to inexpensive art · Membership (exclusive) **GALLERY:** Warm welcome · No barriers to entry Trusted brand · Brand that people know, no justification needed 'Edutainment' · Networking · Access to society Quality art · Good selection of artists · Information/expert talks

(left margin, vertical): A NEW BUSINESS MODEL

(label, vertical): ROOKIE GROUP

▶

DESCRIPTION	VALUE PROPOSITION

ARTY GROUP

DEMOGRAPHIC:
· Across age groups

GEOGRAPHIC:
· Local

ECONOMIC STATUS:
· Highly educated; low income

PURCHASE BEHAVIOUR:
· Frequent attendance at openings
· Highly unlikely that they will purchase a work

PERSONALITY AND LIFESTYLE:
· Engage in critical dialogue with artists
· Interested in content and event

GARAGE:
· Free drink
· Non-profit, independent organization to foster young talent
· Exchange and interaction with artists in easy setting

GALLERY:
· Free drink
· Inspiration
· Networking, exchange

TRADITIONAL GROUP

DEMOGRAPHIC:
· Aged 40+

GEOGRAPHIC:
· Regional, national, international

ECONOMIC STATUS:
· Highly educated, high income

PURCHASE BEHAVIOUR:
· Frequent attendance at art fairs
· Regular buyer

PERSONALITY AND LIFESTYLE:
· Motive: love of art, inspiration, altruistic, collection, investment, return, corporate identity

GARAGE:
· See Rookie group

GALLERY:
· See Rookie group, more focus on branding

Fig. 20

Case Study

DAVID ZWIRNER

The David Zwirner Gallery is among the world's leading art dealers. The Cologne-born founder, David Zwirner, built one of the most ambitious, diverse and successful art galleries in the world. Today, the firm has locations in New York and in London. Zwirner regularly ranks among the top five most powerful people in art. Attributing Zwirner's success to his artists would be both reductive and misleading. The gallery's success has just as much to do with the unique user experience it offers. It is his combination of efficiency, warm-heartedness and openness to all his customers that makes Zwirner a successful gallerist.

Although one of the leading galleries in terms of revenue, with an unapologetic focus on business, Zwirner is wholly accepted by the Arty group, partly because he gets a strong vote of confidence from his artists. In a 2008 Flash Art poll, Zwirner was voted most popular gallery with artists. Diana Thater, who first showed with Zwirner in 1993, is still with him and explains their relationship in an interview with *The New York Times*: 'I'm probably one of the least profitable artists in the gallery, but he never thought to stop supporting me. Even when David and I have had a real falling out, he's stayed loyal to me and I've stayed loyal to him.' Young artist Oscar Murillo, who recently joined Zwirner, remembers his first encounter with the gallery in an interview with *The New Yorker*: 'It sounds like a cliché, but it did feel like a family.'

Zwirner also has excellent and open relations with the press. Every year he holds a press day in New York, to which he invites 120 journalists to talk about future exhibitions. The Arty group are prone to irritation when someone gets too flash, but Zwirner always stays humble, telling Don Thompson in an interview, 'You don't take the spotlight away from artists by having a big personality and attracting a lot of attention; you stand shoulder-to-shoulder with them.' Even his dress code reflects this philosophy—always in jeans and a blue button-down shirt, with the occasional concession to a blazer.

This twin sense of approachability and press endorsement makes Zwirner very attractive to the Rookie group. They want their confidence inspired by a trustworthy brand that simplifies buying art, and Zwirner delivers. Like Gagosian and the other star galleries, Zwirner is always seen at the most important fairs; his galleries in New York and London are in the best locations; the artists he represents are among the world's best; and his customers are superstars, as are his well-known buyers. However, Zwirner differentiates himself in tiny ways. Every employee is featured on his website, making it easy for clients new to the world of art buying to deal with anyone at the gallery. Employees working for Zwirner are a happy bunch, and they enjoy the fact that their workplace is congenial rather than competitive. Many of his employees have been with him since the beginning, and some have even become partners. He also treats his business partners well, even the smaller galleries. Vanessa Carlos, who initially represented Murillo, is quick to defend Zwirner. 'He was very fair. He didn't poach Oscar.'

The Traditional group, too, are happy to deal with Zwirner. In an interview with Nick Paumgarten, Michael and Susan Hort recall a toast they made at a dinner for Zwirner: 'You know, Susan and I are always absolutely sure we get the best piece out of every show. But the amazing thing is that there are ten other people here in this room who feel exactly the same way.'

A not-to-be-underestimated part of Zwirner's success comes from his formidable organization. The gallery's research department easily keeps pace with those of Sotheby's and Christie's, and Zwirner brought in a management consultant to structure the operational part of his business. It certainly seems to be paying dividends. Maybe it is the fact that Zwirner is essentially a 'nice Larry' that makes him so successful and will seal the continuing success of the gallery. Today, it is certainly attracting customer groups across all levels.

Case Study

LIO MALCA

The headline 'New York gallerist opens exhibition space in Ibiza' really caught my interest. Why would a gallerist open on a holiday island, known for its beach flair, techno parties and drugs? St. Moritz, Aspen, Summerset—they all make sense. But certainly not Ibiza, the former (or enduring) hippy party island.

As I realized when I first met him at his private home in Soho, New York City, in August 2015, Lio Malca is not your typical gallerist. Dressed in a T-shirt, surrounded by very impressive Basquiats and Harings, Vik Muniz and Mark Ryden (and two beautiful women), he greeted me from the back of a long living room, where he was preparing outfits for the upcoming Burning Man festival. Not Dia:Beacon, not Art Basel, not Venice Biennale, but Burning Man. He proudly showed me a selection of the costumes and a map of his camp, where he hosts sixty people of a type emphatically different from your typical biennale visitor. In fact, most of what Lio does breaks with existing tradition in the art market, and his unconventionality always attracts new customers. The gallery in Chelsea does not have regular opening hours; exhibitions happen whenever Lio feels like it. The program is rather small, with Basquiat and Haring the focus. And in his Ibiza location, which started with works by KAWS, none is for sale—and it will stay that way. Sara, who is responsible for his PR, politely reminds me that 'our Ibiza space is not a gallery'. Nor is Tulum, where his hotel Casa Malca contains works of art from his private collection or those created for the space. Lio is matter-of-fact about it. 'I'm the worst salesman. I just love art and entertaining people.' This may appear to contradict everything I endorse in this volume, but it is not really so different. Lio simply chooses a different approach. His thorough market knowledge and his uniqueness attract a crowd of collectors that

have been excluded from the art market so far—or were too far removed from it to become active. He has introduced a new set of customers, in line with the group I identified before and classify as Rookies. They spend their vacations in the locations Lio frequents, such as New York, Ibiza, Tulum or Burning Man, and they choose Lio as their gateway to the art world because he creates a unique experience within these spaces—a lifestyle that aligns art and culture and welcomes the public and communities to enjoy it.

Perhaps his lifestyle-dominated approach owes something to the manner of his arrival on the art scene. Born in Colombia, Lio studied finance and economics at Northeastern University and met Haring by chance at a party in New York in the early 1990s. He became part of a social circle including Haring and Basquiat, and began learning about their work. With a profound enthusiasm, he immersed himself in their work, fell in love with it, and has remained so.

Not everyone will be able to replicate a huge house in New York, a gallery in Chelsea, a camp at Burning Man, an exhibition space in Ibiza and his own hotel in Tulum. What can be learned from Lio, however, is that new collectors are out there. In order to capitalize on them, a gallerist must be willing to discard existing customer groups and develop a model that fits these new customers. To put it another way, rather than going to art fairs, work out the natural habitat of your customers and seek them there. Malca found his customers in Ibiza and Tulum, but yours may be elsewhere.

ADVICE FROM LIO MALCA

Only get involved with art that you truly like and enjoy. I believe in my intuition, my gut feeling, my sixth sense.

Only collect masterpieces from artists you like. For me, life, all across the board, is about quality in anything you do. Sooner or later, it will pay off. Let it be for personal satisfaction, market trends, financial reward and self-respect.

Communication Concept

As with so many aspects of art gallery management, most galleries are stuck in a communication concept based on regular newsletters (via email and post) and advertisements in art newspapers. Not surprisingly, this is failing to generate the expected value add. Traditional marketing tools are not hitting the mark with potential clients because clients are simply awash with invitations and news on artists and events. According to the customer segmentation discussed above (and discussed in other resources by my peers), clients want clarity and transparency, reduced risk and personalized offers corresponding to their motives. Considering the vast number of different artists, genres and styles, no individual can evaluate all the thousands of offers in the market before making a purchase. A buyer is going to evaluate only an 'evoked set of products', and quite a small set at that. Art galleries must fight for their space in that set by building a unique brand.

Art galleries must fight for their space by building up a unique brand.

A brand has two functions. On the one hand, it gives an outside-in perspective, meaning art consumers have a certain perception of the gallery. When buyers align themselves with a brand, it is a form of self-expression and a signifier of social status. A brand also offers consumers a shortcut in processing information. It also manipulates the impression of the work itself: consumer perception of quality shifts according to the setting in which it is displayed. For example, a work of art shown at Gagosian is perceived as more valuable than a piece shown in a gallery in Hackney, London.

On the other hand, a brand contributes to the inside-out perspective, and a branded institution can manipulate it to its advantage. A brand allows marketing managers of art galleries to simplify communication with the targeted group.

The stronger the brand, the less information is needed to describe the product and convince people to buy. Take a look at Hauser & Wirth's advertisements. In most cases, they do not even show the artwork, merely the gallery's logo and the title of the exhibition.

Successful examples of art world branding are widely seen in museums. Both the Guggenheim and the British Museum feature the five characteristics of a strong brand: their names are well known; their exhibitions are perceived as being of high quality; their organizations are associated with excellence in their collections, their special events, and even their locations; their visitors are loyal; and they have identifiable tangible as well as intangible assets in their architecture and the quality of their curators.

On the commercial side, Gagosian Gallery or White Cube are branded galleries. Don Thompson, author of the great books *The Supermodel and the Brillo Box* and *The $12 Million Stuffed Shark*, writes extensively on the relevance of brands in the art market. As well as a long list of branded museums, there are branded auction houses (Christie's and Sotheby's), branded artists (Lichtenstein, Warhol, Hirst, Richter), and, of course, branded galleries. These imply status and quality, and they reduce insecurity. Collectors of Gagosian trust his gallery's judgement more than their own. It's often called 'buying with your ears, not with your eyes'.

A strong brand does not initiate a dumbing down of sophisticated product.

A strong brand does not—as critics might argue—initiate a dumbing down of a sophisticated product to suit a consumer-oriented approach. In fact, the effect of branding can be regarded as very positive overall. Various authors have pointed out that branding an art institution and its exhibitions increases visibility and visitor numbers and ultimately generates greater revenue. And of course, shrewd artists such as Damien Hirst or Jeff Koons have demonstrably used successful branding to promote themselves and their work.

A range of communication tools can be used to establish a brand, but the special characteristics of the product must be considered when selecting them. Because the value of art is intangible, communication efforts must be directed towards making its value visible; for example, underlining the popularity of a sell-out show and emphasizing the huge demand for works. Furthermore, customers must be frequently reminded of the whole value proposition and the benefit they get out of it, because it might not be immediately apparent. Below, I describe each communication tool in detail.

Advertising/Newsletter/Direct Mail

Advertisements and newsletters via email or post represent the central traditional communication tool in most art galleries. My survey, however, shows clearly that it no longer works. With apologies to Boris Brumnjak of Gallery Print, who counts many galleries on his client list, galleries should cut out printed invitation cards as an overhead. If a strategy is followed by almost every gallery, it becomes invisible and does not generate any meaningful extra revenue.

Gallerists need to tailor marketing messages, target the right customer with the right value proposition, employ functional customer relationship management (CRM) technology, and track customer status. CRM systems such as Artbinder.com or Gallerymanager.com are indispensable for spending minimal time on the administrative workload. They will not only help to organize effective personalized approaches for customers but will also lighten the workload associated with invoicing and PR tasks, such as collating digital photographs, biographies, press releases and catalogues for press and other conceptual art mediators.

5.6.2
Personal Selling

Personal selling is the fundamental communication tool for any gallery, and it should be the standout competency of owners and staff members alike. Personal style is key here. The documentary *Super Art Market* shows how Galerie Eigen+Art owner Harry Lybke tries to sell a work to a collector by creating a sense of urgency. Jeanne Greenberg-Rohatyn (see case study: Salon 94) has used her undoubted charisma to great effect, bringing not only celebrities such as Jay-Z but also traditional art collectors to her door.

5.6.3
Exhibitions

Exhibitions can be thought of as packaging around the product they are selling. They are a key communication tool for sales. In museums, for example, blockbuster shows are the most frequently visited, and galleries can adopt a similar big-banner approach to shout loud and clear to the uninitiated, the suspicious and the apathetic: 'This Is For You'. However, attention should not be sought at any price. Jeffrey Deitch's preference for flashy, fashion-forward Los Angeles shows that drew more from pop culture than from the academic world (such as *Fire in the Disco*) eventually led to the resignation of several artists from the MOCA board. So picking the most popular products might well be a short-term strategy that will not gain the approval of the art community. It is about finding a new product that is different, one that can get on the public radar and provide a platform for meaningful interaction and participation by new people. It's also about finding the right balance.

A first step is naming exhibitions differently. Often the artist defines the title, because it is part of the show, but every gallery tries to find a title that captures the quality of the show. It is one of the key selling tools at their command. The auction

house Phillips, in their previous incarnation as Phillips de Pury, framed shows with titles such as *China* or *BRIC*, which had far more impact on the crowd than a rather lifeless title like *Art from Asia—Perception of Reality*. Framing exhibitions with a title that reduces complexity, making it clear to the public what the exhibition will deliver, demolishes barriers to entering a gallery and purchasing something. As we discussed earlier, Hirst pulled a similar trick, though somewhat in reverse with the lengthy title *The Physical Impossibility of Death in the Mind of Someone Living*. The point is: titles have power.

Events/Art Fairs

With an average of six annual exhibitions, galleries organize at least that many openings during the year. Every opening should be treated as an opportunity to create something that stays in the mind of the guests, but most gallery openings are sadly similar. Wine and water are served, mostly to the same crowd. Sometimes the artist is present and is introduced by the owner to potential clients. The Opening Crowd leaves names in a guestbook, so to be sent the gallery newsletter. Sales at the opening will always have been brought to the point of closure by the gallery owners before the event. It is exceptionally rare for an unknown buyer to appear on the floor and purchase a work at an opening.

In my new model, openings play an increasingly important role, and galleries must submit to a certain amount of hype creation in order to maximize opportunities to sell. Red dots next to a painting are historically the strongest signal that a sale has been made. This creates a dynamic in the Opening Crowd that might motivate an undecided buyer to close the deal.

Art fairs, which are even more of a key selling platform for art galleries, should also be vigorously worked as an opportunity to sell, using similar communication tools. At art fairs, a gallery can differentiate itself from international competitors

and add value to its brand. It is critical to make the most out
of an art fair, since the costs of participation can be daunting.
A single booth at Art Basel is $680 per square meter (10 sq.
ft) or $55,000 for an average booth; at Frieze New York it is
$53,000 and at The Armory Show $35,000. Smaller fairs,
such as Pulse or Scope, and satellite fairs, are cheaper,
increasing exposure at only 50% of the cost.

Word of Mouth in Communities

Word-of-mouth promotion is one of the most effective
forms of advertising for any product, but it is also the most
elusive—and the most dangerous, should reviews not go your
way. The unquestioned authority of word-of-mouth reporting
is rooted in the status of the reviewer: with opinions delivered
in a personal and casual context, reviewers are seen as trust-
worthy, independent and in some way similar to the recipient.
The reviewer is also responsive to questions, unlike an
advertisement.

Particularly in an industry where advertising budgets are
limited, word-of-mouth promotion is of huge importance. So
far, art galleries have not managed to find reliable ways of
garnering this type of publicity. The next two concepts offer
new ways to attract it.

Integration

A proven, powerful tool to attract new customers and create
word-of-mouth promotion is to link influential, art-loving
people with the gallery. One route is to get them involved as
shareholders, but this can bring its own problems. A more
temporary and quasi-formal way is to give them *carte
blanche*—offer an invitation to organize and curate a show in
the gallery to a highly influential and well-connected art
world figure. This idea was deployed to great effect by Phillips

de Pury in 2010 when dealer Philippe Ségalot created a single, well-publicized sale from works owned by his clients. This innovative idea associates powerful opinion makers with the gallery in an event that has considerable appeal to press and public alike. Both have a keen interest in seeing a prominent person openly displaying their taste by curating an exhibition. Those opinion makers will also bring in a network to see their show, allowing the gallery to work the crowd and seed its name. Allowing associates to make a temporary home in the gallery strengthens the commitment of these people and their friends towards the gallery.

Openings present another chance to integrate people and win new clients. Galleries can court potential clients and take the opportunity to convert the attending crowd into message bearers through giveaways. A simple giveaway might be something portable, such as a small bracelet, or an edition of a drawing or painting, which visitors take home. The attention that these giveaways attract among the message bearer's social circle will draw visitors to the gallery. In particular, the artist could be asked to come up with creative but cost-efficient ideas that will create word-of-mouth promotion.

The underlying energy in the garage concept is intrinsically linked to the idea of networks and word of mouth. The garage should be a place of interaction, a playground and discussion forum for the art scene, online and offline. It is, therefore, important for galleries to form close collaborations with art students and art academies alike. This will not only spread the brand through these people and their friends and networks, but also across those that wish to be affiliated with the local emerging art scene.

5.6.7

Participation

Client participation— inviting customers to get involved in the creation and exhibition of art—creates considerable word-of-

mouth promotion. For example, in the run-up to an exhibition, the gallery should not be closed to the public while the exhibition is built. On the contrary—it should open its doors and invite interested people to join the construction of the show. Similarly, customers should be invited to join an artist at work. Most artists fear studio visits; however, ambitious artists who want to be successful would do well to consider welcoming visitors to see them at work and wooing them as future buyers. Artists could also transfer their studios temporarily into the gallery space to attract passersby. A great showcase is artist Ugo Rondinone, who converted an abandoned church in Harlem, New York City, into his studio and who invites friends to show their works there.

Gagosian Gallery had an inspired idea for customer participation with the Spot Challenge. Multiple Gagosian galleries simultaneously exhibited Damien Hirst's *Spot* paintings, and anyone who visited all eleven galleries and got their card stamped received a limited-edition Hirst print. The take-up was huge. Jeff Chu, a writer for Fast Company, and Valentine Uhovski, from the website Socialite Rank, completed the challenge in eight days (which is incredible, considering Gagosian's galleries are dotted around the world). In all, 128 travellers completed the challenge and earned a print worth $6,000.

At this point, it is worth remembering that every communication activity should be aligned with the goals of an art gallery. This means that communication efforts cannot be directed solely towards maximizing profit, but must hold up under ethical scrutiny and keep the artistic value of the value proposition in mind. With the Spot Challenge, it was all about fun.

The following table summarizes all details of the communication concept and how it relates to each customer category.

EXAMPLES FOR A COMMUNICATION
APPROACH FOR EACH CUSTOMER CATEGORY

APPROACH

ARTY GROUP

GARAGE:
Advertisement:
· Only online newsletters, blogs
Personal selling:
· Selling not the focus, exchange highly important
Events:
· Events created through show
Integration:
· Collaborate with art academy
· Win influential people from scene to curate a show
Participation:
· Allow visitors to participate in show

GALLERY:
Advertisement:
· Online newsletter
· Highly selective, personal invitations only if strictly relevant
Personal selling:
· Selling not so relevant, introduction to artist more important
Events:
· Present media with an innovative and clear concept
Integration:
· Win influential curator or critic to curate show
Participation:
· Invite them for studio visits

ROOKIE GROUP

GARAGE:
See above with heavy focus on personal selling

GALLERY:
Advertisement:
· Online newsletter
· Highly selective
Personal selling:
· Selling highly relevant
Events:
· "Edutainment"— entertainment and education
· Use signals (red dots, sounds, signs) to create dynamic atmosphere
Integration:
· Win High Net Worth Indivi dual to curate show
Participation:
· Invite them for studio visits

TRADITIONAL GROUP

GARAGE:
See above with heavy focus on personal selling

GALLERY:
See above with heavy focus on integration and participation

Fig. 21

Case Study

SALON 94

Art Brat, It Girl, judge for Bravo's reality series, Cultural Tastemaker—the list of descriptions for Jeanne Greenberg Rohatyn is long, but I would like to add Marketing Genius to her list of accolades. Daughter of a respected dealer, Jeanne founded her gallery, Salon 94, on New York's Upper East Side in 2003. In 2007 she opened an additional location on New York's Lower East Side, following up with the third location on the Bowery in 2010, next door to the New Museum. Today, the gallery has fourteen full-time employees and six freelancers.

Jeanne considers her clients to be the artists she represents, and she is not only uniquely imaginative in her approach to marketing their work but is also ardent in her belief in stretching boundaries for both artists and audiences. I visited her in the Upper East Side gallery to learn more. She summarized her approach with a single word: 'packaging'. When I looked confused and clearly none the wiser for this succinct explanation, she expanded on it. 'I create additional value around my artists' work. I call them packages, but really it's a sort of creativity to unlock a new level of looking, a new level of desire.'

Jeanne's approach is to link the artists with different industries, combining the worlds of fashion, sport, entertainment and the arts. Katy Grannan, the American portrait photographer, shot works commissioned by *The New York Times*. Marilyn Minter shoots advertisements for Tom Ford and Mac Cosmetics, and Nate Lowman shows his works in baseball player Alex Rodriguez's home (they hang around his new indoor, upper-floor batting cage). Probably the most widely publicized package was with her

client rapper Jay-Z, when she set up a music video shoot for 'Picasso Baby' (the art-centric song from his album *Magna Carta ... Holy Grail*) at the Pace Gallery in Chelsea, New York. To add to the buzz around the video, quite a few art community names participated in the video, among them Lorna Simpson, Mickalene Thomas, Lawrence Weiner, Andres Serrano, George Condo, Yvonne Force Villareal, director of the New Museum Lisa Phillips, and MoMA's president emerita Agnes Gund.

Bringing these different worlds together is a refreshing and highly individualistic strategy. When *The New York Times* published Grannan's work, or when Tom Ford uses Minter's photographs on billboards around the world, these artworks are not just seen, but seen in a wholly new way. 'This way, I attract a whole new group of people who aren't from the art world. For me, magazines are additional walls to reach a new audience.' By reaching this growing audience she heightens her artists' messages and stretches their vision. The Jay-Z event, for example, created a whole new dynamic, sparking enthusiastic debate among the audience about the use of visual art to express music.

Jeanne applies a similar strategy to her personal work. She has been written about in almost every leading magazine. She became known to millions of people outside the art world as judge on the debut season of Bravo's show *Work of Art: The Next Geat Artist* in 2010. Packaging continues in her own gallery space. Her gallery on the Upper East Side is her own house, where she has lived with her family since 2002. 'This allows me to work from home, even if it means opening my doors to the public by appointment.'

Of course, being popular in the art world is not always good. People are fast to judge Jeanne's activities as very commercial. Some might even fear that the art suffers under the influence of paid advertisement. In practice, for Jeanne's artists, it is the opposite—they get great feedback from the art community. This is a model that has worked to everyone's advantage, and it lends

considerable weight to the argument that there is a time and place when culture and commerce can be usefully combined.

ADVICE FROM JEANNE GREENBERG ROHATYN

Think out of the box. Break the rules.

Take each artist individually and create a package around the goals that make sense.

Case Study

STEFAN SIMCHOWITZ

Stefan Simchowitz is someone who spares no expense. In fact, he takes chances in business most others would shy away from. His approach is different to the traditional gallery model, with a keenness for risk-taking and an aversion to existing standards. He has paved the way for art market darlings such as Colombian Oscar Murillo, the Iranian-American artist Kour Pour, post-Internet stars Petra Cortright, Jon Rafman and Parker Ito, and many other young artists, all under the age of thirty-five. But it has also earned him the title of Sith Lord and Art Flipper, and he is today among the most controversial figures in the art world. Putting personal feelings about his methods to one side, it is worth investigating the Simchowitz model. He could best be described as an early seed investor, with two specific aims: first, to create a growing and sustainable business, and second, to make an attractive ROI.

Stefan's model has three key steps.

Step 1: Stefan invests in emerging artists at an early stage by buying large amounts of their work at a cheap per-unit price. This is a risky endeavour. While galleries work mostly on commission, with no money transferred to the artist until a work is sold, Stefan does the cash-out, spending money up front. He usually invests $100,000 in an unknown artist. For this he gets between thirty and fifty works that are, as it stands, difficult to sell because there is no market for them—yet. Put yourself in the position of a young artist: you don't have enough money to produce your work, and if a gallerist works with you, you only see the money when a sale is made. Any artist in that situation is going to be tempted by Stefan's investment, because the initial monetary inflow allows the artist to work efficiently and consistently. Or, as Stefan explains:

'Working capital is the keystone to success. You need it to start, and you need it to continue. The artist is a producer of cultural production and is by no means immune to the requirements and needs of any small business.'

Step 2: With this heavy financial outlay, the hard work begins for Stefan. He calls it 'creating a heat and velocity'. Rather than leaving it to them, he actively accompanies his artists in their developing careers, making sure that marketing, sales and distribution systems are functioning successfully. Like any other investor, Stefan wants to see his investment succeed. 'We need to make sure the artist succeeds now. We are tied to the front line with the artist, because we own the material.' It is the job of any gallerist, but Stefan is remarkably successful—perhaps because he feels more pressure. While gallerists carry (only) the weight of overheads, such as rent and other practical concerns, Stefan needs to see a return on his money.

Another key to his success is his marketing approach. On the one hand, he reinvests in the artist's career by financing shows, books and non-commercial projects. On the other, he is brilliantly successful in instigating a new brand—the Simchowitz brand. Almost every newspaper around the world has reported on him, often showing him in provocative photographs. And he is clever with social media. His Instagram account has more than 70,000 followers. Perhaps this does not sound like much compared to Beyoncé, but for an individual in the art world, it is huge, almost as many as the David Zwirner Gallery. And it works for his customer group. His collectors are not the old school, traditional collectors. They are drawn from what I would classify as the Rookie group— essentially a network of celebrities, such as movie stars and football players, and from poker players and successful business individuals who understand Stefan's investment philosophy.

Step 3: When these marketing efforts pay off, demand and prices increase. These are the perfect market conditions for Stefan, because he is controlling the supply. He is at the center of the

system, the one closest to the artists, sitting at the entrance of his studio and deciding who goes in and what goes out. 'I manage volume and price, and maintain a close eye on supply and demand, like any good wholesaler or financier, to maintain a sustainable market for the artist.' Interestingly, Stefan doesn't do contracts. 'I don't make contracts and just trust that I'm doing a good job. Often artists leave too early—the results speak for themselves.'

To conclude, although he attracts a lot of attention, his business model is not entirely new. Buying in bulk, creating a market for it, and selling it subsequently has been done before by the likes of Robert Scull and Charles Saatchi. Like Simchowitz, they treated art as a commodity, they were shameless self-promoters, and they consequently became the most talked-about men on the art scene. Even the protests from artists and other knights of the art world against its commercialization were surprisingly similar. Love it or loathe it, it is likely that we will see more of this model of enterprise and the debate that surrounds it.

ADVICE FROM STEFAN SIMCHOWITZ

Call 917 691 8440.

Don't listen to bullshit from third parties. Do your own homework and unlearn everything you have been taught; you have been programmed to fail.

Reve**5.7**ncept

Revenue models do not vary much from one gallery to another. Most revenue streams are limited to the primary market, with no income generated through extra services. Only a fraction of the galleries I observed operate in the secondary market, despite the fact that it seems to generate the highest profits. Rent and salaries are the biggest overheads, closely followed by art fairs. Galleries need to identify innovative new income areas to give their revenue models a boost, while offering attractive pricing models and cutting costs through operational efficiency.

For business students, the revenue equation is always a good starting point. When profit equals revenue minus costs, and revenue is quantity x price, I start with quantity.

5.7.1
Quantity

DIVERSIFICATION

Under the three-pillar structure that I set out in my new model, galleries must have a presence in all three phases of the artist's life cycle in order to secure a constant revenue stream. Focusing only on the primary market, as most galleries do, is a high-risk strategy. Competition is at its most intense in contemporary art, exposing galleries to a dynamic yet highly volatile market. Galleries must therefore extend their revenue model to include the secondary market. Although it will be difficult to build up new competencies, there is compelling evidence that galleries operating in this market are performing better than those that do not.

MULTIPLICATION

In the USA, the role of art advisor is far more advanced than in central Europe. Galleries should start to liaise with them,

paying the usual commission of 10–20% if a sale results. Gallerists should also be broadminded about what constitutes an advisor: like the friends recommending friends scheme often used by consumer banks or HR departments, an agent can be anyone, ranging from bored but influential socialites to industry CEOs. Advisors come with no fixed overhead for the gallery owner, usually have a strong relationship to the gallery brand, and serve as a free multiplier of the message.

EXTRA SERVICES

The gallery owner, as an art market expert, can offer expertise as a speaker at events. The increasing number of art market publications, documentaries and art management degree courses demonstrate the public's interest in the art market. The gallery owner can satisfy this interest by offering to speak at conferences or corporate events, or perhaps also by organizing a lecture series under titles like 'Management of a Gallery', 'How to Make Money in the Art Industry' or 'Stories from a Gallerist'. Circuit speakers earn an income, and if the gallerist chooses to stage events, participants will pay a fee to attend. Furthermore, regular appearances at talks and events establish a gallerist's reputation for expertise, transparency and trust. Galleries may also offer extra services surrounding the product, such as home delivery and hanging, services that most buyers are willing to pay for.

Galleries could also rent out exhibition space as an additional income stream at minimal cost. A gallery with white walls and regularly changing art offers the optimal space for special events such as dinners, photoshoots, talks or private receptions. Clients enjoy the special setting and atmosphere, as well as the reputation, that accompany the image of a gallery. Disruption is fairly minimal, because the gallery cannot be changed or works removed. The gallery, meanwhile, gets access to potential new clients, particularly if the event host is a company that typically features High Net Worth Individuals among its clients, such as a private bank.

It is, however, highly important to keep organizational and administrative duties to a minimum. This might be a reason why so few galleries employ this model. As far as I have been able to tell, only a fraction of galleries are offering themselves as a venue. However, business partners can be helpful here: galleries can seek out specific expertise by teaming up with catering or conference technology companies, but the pricing model should be kept as simple as possible.

ARTIST STUDIOS

Interestingly, galleries classify artists as their third biggest competitor, because the practice among artists of arranging private transactions and hiding this income from their galleries is rife. Galleries must access these revenue streams through punitive contracts.

5.7.2

Prices

A much under-exploited means of increasing profits is price: it is so basic but so completely underestimated in the art industry. Price is the most obvious signifier of the status of the dealer, the reputation of the artist and the status of the buyer. Prices usually start for an artist with no gallery history at $5,000—a figure nicely judged to be high enough to convey the value and low enough to be acceptable for a first show. If the same work is exhibited in one of the top galleries, it will probably be priced at $15,000, simply because the gallery's profile is higher.

The theory of pricing by reputation is not new. A Gucci handbag costs more than an equivalent bag without the Gucci logo. Economists call this the Veblen effect: buyer satisfaction comes from the art but also from the price paid. The flip side of this psychology is that galleries cannot officially discount a price—this can send buyers swiftly into reverse, because the product is no longer perceived as exclusive or high-status.

Safer ways to play with price are price differentiation, price bundling and price variation.

Price differentiation is based on the idea that similar products can be sold at different price points by the same provider. The rationale behind price differentiation can be based on several criteria, including location, time and personality of the buyer. Price differentiation is a useful tool in enlarging quantity of output.

(1)

Location: Based on the location of the sell, the gallery can charge different prices. A piece that is shown in the context of a garage exhibition can be sold for less than the same work shown in the gallery. The garage partly depends on the notion that it is a place for early adoption; upcoming artists can be spotted and bought while their works are affordable. A showing in the gallery, on the other hand, indicates a higher demand for this artist. The extra charge at an art fair is underpinned by a similar logic.

(2)

Time: Galleries can increase the number of transactions by offering a special reduction for selected works on the last day of the fair or before Christmas, to promote impulse buying.

(3)

Buyer demographics: Market segmentation can be used to devise detailed and specific offers on a demographic basis, perhaps with the Arty group and particularly with the Rookie group—a high-value acquisition in customer terms. For example, for every art buyer under thirty years old in these two categories, a reduction of 15% might be granted.

Some of these ideas are more widely practiced than you
might think. A gallery already sells at a different price at an
art fair (location); they often agree a preferential price with a
prominent collector (buyer demographics); and it is not
uncommon to drop the price when a work has been left unsold
for quite some time in the warehouse (time).

PRICE BUNDLING

Frequently used by galleries, price bundling combines various
works sold at a price lower than the sum of its parts. Price
bundling is even more effective when linked to a percentage
discount contingent on closing the sale by a deadline.

PRICE VARIATION

Price variation simply means to vary the price of a given
product. This is often done during a sales period, when prices
for all products are reduced.

5.7.3

Costs

GALLERY ROOM

For galleries, rent is the highest cost, and particularly for
city galleries, 81% of which are in prime locations. Art
Enthusiasts and the Opening Crowd, neither of whom have
any potential as buyers, form the biggest groups of visitors
to a gallery. Real potential clients do not just show up
randomly; they organize their visits in advance. Galleries
must therefore ask themselves why they maintain expensive
space in prime locations when the benefits are relatively small.
My new model suggests reducing fixed costs in three ways.

(1)

First, the garage concept can be rolled out in a variety of
cheap rooms that are available for short-term rental. The
gallery can follow a similar concept with more exclusive rooms,
rented on a pop-up basis for the length of the exhibition.

Alternatively, a room can be rented for a longer term, but not in the city centre. Industrial areas usually form a cheap yet inspiring, often fashionable alternative for showing art, with the added bonus that parking space is less of a problem. Almost every potential buyer drives, so public transport connections are less important.

Finally, locations can be shared with partner galleries to reduce rental costs and to co-promote, drawing additional attention to the location. For example, Andrew Kreps and Anton Kern opened a temporary space in San Francisco together in 2016. Meticulously maintained boundaries between galleries are absolutely essential if commercial disputes are to be avoided. Each must also be careful to preserve its own profile, unless a merger is envisaged.

ARTISTS' SHARE OF REVENUE

To the gallery, the artist's share is the cost of goods sold, and 50% of a gallery's revenue goes straight to the artist. However, the gallerist is bearing all the impact, and often volatility, of increased art fair costs, strong global compe-tition and marketing efforts. My new model therefore pro-poses a revised ratio of between 30% and 70%, depending largely on the maturity and popularity of the artists. I will elaborate on this idea below.

FLEXIBLE SALARIES

Art gallery employees should be paid a flexible salary of base plus bonus, depending on their ability to generate revenue. Particularly in times of crisis and low-revenue years, salaries can remain low, but the employee is still offered a powerful incentive. I discuss this further in the Gagosian Gallery case study on page 123.

Case Study

ROD BARTON

Rod Barton is a good example of a gallery that became successful while keeping costs low. Rod founded his gallery in 2009 and today employs one full-time and three part-time employees as technician, art handler and book-keeper. Originally trained as an artist, Rod worked for two years for Gagosian Gallery in London and for six and a half years as a studio manager for a well-known British artist. The gallery exhibits artists such as upcoming superstars Chris Succo and Oliver Perkins. It was Chris who referred me to Rod when I told him about this book project during a studio visit in 2014.

Rod's strategy for success is simple, as he explained in our interview: 'I keep costs low.' He opened his first gallery in 2009 when he was still working full time. This allowed him to cover his living expenses while running the gallery space. He chose a cost-effective alternative space in Clerkenwell, London—a residential and media industry area, but certainly not a gallery hot spot. Rather than employing someone to keep the gallery open throughout the week, he decided to open only on Saturdays. His strategy was simple: 'With almost zero overhead, I didn't have to sell. If I sold one painting, I've done well.'

When the time was right, he quit his job and started his full-time gallery career. Again, he kept his costs low: 'Rather than heading for the city centre, I moved the gallery to south-east London. I wanted to be in an area where I could get a good-sized space for a low rent.' Keeping costs low did not just apply to rent; Rod also takes a strictly economical stance with marketing. He does not do

mailings or extraneous printed matter, but is active on Facebook, Instagram and Twitter.

Rod's economical and entrepreneurial approach has paid off, with his gallery now thriving and expanding. The first thing he did to ensure this was to use his tactical business acumen to survive the first few years. Most galleries do not survive because they start out with high overheads but little income. Second, by keeping out of the spotlight he did not overexpose himself to market pressure. He could do the shows he wanted, with artists with whom he wanted to work, without being dictated to by sales and revenue. It is a freedom most starting galleries do not have. The third thing Rod did was to establish a foot in the art market by developing a deliberate and sustainable network. This cautious approach has appealed to his artists and collectors, fostering established and durable relationships.

Today, Rod is producing a seven-figure revenue and he has positioned himself as a catalyst for young artists. He has had his share of defections, with artists leaving for bigger galleries with larger exhibition spaces, more assistants and more prime locations. However, he is not worried. 'These things happen, but that won't stop me', he says, with the smile of a man who has his finances and vision firmly in control.

ADVICE FROM ROD BARTON

Be original, and true to your belief of what good art is. Don't follow the crowd.

Keep costs low and only do what you can afford.

Growth Concept

To the extent that growth concepts exist at all, they rarely differ much between galleries. In the main, however, growth concepts have been given no serious thought by gallerists.

Why growth? The typical art gallery is a very small enterprise with few employees and little revenue. Almost 90% have no subsidiaries, operating out of one address with no other national or international representation. There are, however, some rare examples of galleries that have several subsidiaries and show no sign of stopping. Gagosian, for example, the world's largest art gallery, currently has fourteen galleries worldwide, while the Zurich gallery Hauser & Wirth currently operates from six galleries around the world (although they have yet to open in Asia).

Their motivation to grow is two-fold. Initially, they wanted to meet economic goals, such as leveraging revenues, increasing margin or profiting from currency differences. Secondly, growth meets psychological goals. Galleries operating internationally are closer to overseas customers and artists, their international presence creates customer satisfaction, they increase brand awareness, and they can react faster to trends. Moreover, international presence lends galleries an aura of professionalism, exclusivity and reach that only the best galleries in the world possess, as Sprüth Magers will attest.

Almost 90% of galleries have no subsidiaries, operating out of one address with no other representation.

But how to grow? In order to foster growth, galleries need the necessary resources and a clear determination to grow, stated through their strategic mission and implemented through their goals. This might be the reason why so few galleries grow; they either do not command the resources (the infrastructure, employees, or budget) or they have not

identified growth as a goal in their business strategy. A gallery that does want to grow can follow several different approaches.

Enter new markets: Galleries can identify new markets to enter in a different country (China, for example) or even just a different city. The route can be slightly eased through partnership with another gallery in the target location. As I will discuss below, collaboration with an existing gallery on the basis of sharing the space or exchanging artists is a useful way to enter a new market without investing too much capital. Another possible entry solution is to participate in an art fair. This helps in meeting new clients, although it can be difficult to keep in regular contact. Finally, the most basic (and resource-intensive) way is to rent a gallery space and open up in a new location.

(2)

Extension of share of wallet: Galleries can try to grow by extending their share of their client's wallet, for example by offering extra services over and above the existing product or developing interesting pricing models.

(3)

Franchising: Franchising is a commonly applied growth concept in the business world, particularly in retail, yet completely unused in the art world. Once a gallery has established a decent group of artists, it can offer its programme and artists to a franchisee. The franchisee will be allowed to change the program only marginally, for example by adding a local component. At international art fairs, the franchisor will participate to promote the artists. This concept has, to my knowledge, not yet been applied. It would be interesting to see its application.

Case Study

SPRÜTH MAGERS

The story of Sprüth Magers, one of the world's top galleries, is a case study in steady and carefully timed international expansion. Monika Sprüth and Philomene Magers run galleries in Berlin, London and Los Angeles. Today the gallery represents over fifty artists, among them such superstars as Ed Ruscha, Andreas Gursky and Cindy Sherman. Its growth, however, was not driven by an internationalization strategy with profit projections at its heart; rather, it happened almost organically, as these two artist- and client-centred owners recognized changing needs among their artists and customers. The result has been massively successful.

Sprüth Magers started as two separate concerns in Germany. Philomene Magers is a native of Bonn, and her mother ran a gallery there. When Philomene met Monika Sprüth, Monika was running a gallery in Cologne. 'We decided to merge in 1998 in Cologne', Philomene recalled when we met in her favourite café in Berlin Charlottenburg. Changing market conditions in Cologne, combined with personal reasons, encouraged them to open a joint venture in a new city. Like many German galleries at the start of the twenty-first century, the famous art hub of Berlin was the favourite choice for relocation. However, things turned out differently. 'Over the Christmas of 1998–99, the idea of opening in Munich rather than Berlin started to take hold. When I spoke to Monika after my holiday, she had been thinking along the same lines.' Six months later, they opened their gallery in the hip Schwabing area of Munich. It was a decision based purely on feeling, with no real rationale. To this day, still

shunning the direction of the crowd, they do not want to be part of the Berlin gallery hype.

Nine years later, nonetheless, they made the move to Berlin. 'Our gallery's artists were all keen to exhibit in Berlin. And we wanted to show their exhibitions to a larger crowd that engages in a dialogue.' This focus on artists' wishes and on working for their benefit plays a dominant role in Sprüth's and Magers' decision-making processes. 'The artist's interests come first. Profit comes later.' In 2003, they opened in London. Again, this decision was largely influenced by the gallery's artists. Germany, and particularly Berlin, is a great place for artistic debate and has an active collector base. However, it is not international. 'London is Europe's art hot spot. We just needed to be there.'

The opening of the Los Angeles space in February 2016 marks the gallery's truly global presence. A gallery in New York might have been the more obvious move, but interestingly, Sprüth Magers has begun its US entry by opening a 1,300-sq. m (14,000-sq. ft) space in California. 'For us, LA is very much like Berlin. We really love the energy. It fits well with us and our spirit. And many of our artists live and work here, like John Baldessari, Ryan Trecartin, Barbara Kruger, Sterling Ruby and Ed Ruscha.'

It seems that the expansion story of Sprüth Magers isn't yet at an end.

ADVICE FROM PHILOMENE MAGERS

Be passionate about the arts and share your love.

Social skills are important. Be a networker.

Case Study

11R (FORMERLY ELEVEN RIVINGTON)

11R was co-founded in 2007 by artist and curator Augusto Arbizo and established on 11 Rivington Street on the Lower East Side in New York City. The gallery opened as an outpost of Van Doren Waxter, focusing on emerging and international artists. Augusto is director and partner of the gallery and has developed it into a successful business, with four full-time employees. Augusto is currently in a transitional phase. He explains: 'In the past eight years we built up a vibrant business with great artists. Now I want to grow and enter the next level.'

The first part of Augusto's growth strategy was to increase the size of the gallery. In 2012, he expanded from his 60-sq. m (650-sq. ft) space at 11 Rivington Street to a 110-sq. m (1,850-sq.ft) storefront space at 195 Chrystie Street, only a stone's throw away. For three years he maintained the two spaces, but he is now consolidating his business at the second location, enlarging it to a footprint of 300 sq. m (3,230 sq. ft). When I met him in his gallery, Augusto explained the nearly fivefold expansion of the gallery's original size. 'Artists enjoy exhibiting in larger spaces. It gives the exhibition the aura of a museum. In addition, our lease on 11 Rivington was about to end, and we had some luck with the other location. The owner liked the idea of an art gallery on the premises, and offered us a good deal.'

Second, Augusto is working to increase his customer demo-graphic. 'I strongly believe in art fairs. Here, I can meet new clients and develop conversations. It's a marketing tool.'

Augusto has doubled his art fair presence from up to three a year between 2012 and 2014 to five in 2015 and a planned six in 2016. He has also learned to maximize the value of fairs with a clear game plan. He always decides in advance which collectors and curators he wants to meet and invites them to dinner during the fair, usually with another gallery. The artists he chooses to exhibit also depend heavily on the fair. He recalls one fair in 2015: 'I knew that the curator of the museum was interested in one of my artists, so I did a solo show with him. Obviously, the entire board came to check him out. I was then sold out.' To increase his impact, he never attends just once but always goes at least twice to the same fair. Augusto is also active in the secondary market, but he has a different and very personal secondary market approach. He is not the sort of dealer who sells works of art from his computer. He organizes shows with underrated artists who are traded on the secondary market. 'I create my own secondary market. I do what I'm best at, which is organizing a show, getting my existing collectors in, and selling the works—not with a jpg, but by standing in front of the artwork.' In this way he avoids competition with other dealers who have a much larger network and better access to rare pieces. He plays to his strengths, doing great shows on his premises. His first show with Moira Dryer in 2014 proved to be successful, and he put on a new show of her works in early 2016.

What I like about Augusto's development strategy is that he grows organically. Without external funds, he decided that his opportunities for growth are best effected via diversification (as seen at the Dryer show) and by enhancing existing sales channels (through art fairs and gallery size). He also realized that he needs to underpin his ambitions by supporting his management team, seeking a new gallery director to take on most of the daily gallery business, freeing him to devote his enthusiasm and skill towards a very successful secondary market practice.

ADVICE FROM AUGUSTO ARBIZO

Have a true love and deep connection to the work you are
exhibiting and promoting.

Practice good business.

Competence Configuration

In competences as in so much else, art gallery profiles are markedly similar. While 99% of owners rank their social and selection competency above average, their management skills score only an average value, suggesting that they must gain competencies in management, marketing and selling in order to achieve the perfect balance between the value proposition and skills.

Today's art managers are faced with a dual challenge. On the one hand, they must reach out to the market with artistically excellent products and create an understanding for them. On the other, they must look inwards, and professionally run their management and marketing approaches in a changing environment. However, while their work demands a balance of the two competencies, key personnel in art organizations are primarily experts on the artistic side and are only secondarily managers. My new model emphasizes that this must change. In order successfully to manage an art gallery in the future, employees must possess management knowledge. This requires skilled managers who are familiar not only with the arts, but also with sophisticated management techniques. Employing art history students with no management skills, as has been the norm, is no longer an option. The focus has shifted from artistic concerns to the quality of the organization's management.

Gallerists should consider three recruiting selection criteria: art knowledge/passion, managerial skills and social competence.

Gallerists should consider three recruiting selection criteria: art knowledge/passion, managerial skills and social competence. This helps to clarify expectations of the new employee and to evaluate potential job applicants more effectively. Hence, it might be more useful to employ a more mature (and more expensive) marketing manager who will bring in a

network and has the social competence to sell a work of art. It was no accident that Marc Steglitz, from the Guggenheim Museum in New York, has an MBA and worked for a bank, nor that Jeffrey Deitch, former director of MOCA in Los Angeles, holds an MBA from Harvard Business School.

Salary is an important issue in attracting suitable candidates. It is common knowledge that the art industry pays a lower salary than other industries, relying on employees with the passion factor who will trade money for the prestige of a job in the arts. The best-educated people, however, will almost always choose another industry to work in.

Art gallerists who want to attract excellent people must understand that they are up against firms like LVMH or P&G.

Art gallerists who want to attract excellent people must understand that they are up against firms like LVMH or P&G, and their salary propositions have to be competitive. Art galleries have the advantage over firms such as LVMH in that they can create broader and more enticing compensation packages. While the base salary can be comparatively low, they can offer a bonus based on revenue generated, flexible working hours, a low hierarchy context, an impressive job title and access to powerful people—and still exploit the 'sexy business' image.

Gallerists should select their channels carefully to reach potential employees. A business magazine or website is more likely to produce quality applicants than a specialist art newspaper; a bit of research within the alumni networks of business schools or marketing faculties of universities can lead to useful introductions. Headhunting from a competitor or indeed from a completely different industry could be a good option. Finally, management graduates from within an inner circle of family and friends may prove to be valuable.

The following table summarizes the key characteristics of a gallery employee.

KEY CHARACTERISTICS AND DESCRIPTION
OF GALLERY EMPLOYEES

JOB DESCRIPTION

GARAGE

JOB TITLE:
· Director

LENGTH OF EMPLOYMENT:
· Employed for two to four
 shows a year

RESPONSIBILITIES:
· Curate 2-4 shows a year
 with emerging artists
· Solely responsible
· Artists must:
 - Be under thirty
 - Have only marginal
 experience in the art
 market
· Communication tools:
 - Facebook, Instagram,
 blogs

· Annual report:
 - Includes a statement
 of income and reports
 with pictures of past
 and upcoming
 exhibitions

SALARY:
· Low base salary

PROFILE:
· Preferably art student in
 art academy
· Affiliated with/connected
 to the art scene

GALLERY

JOB TITLE:
· Director

LENGTH OF EMPLOYMENT:
· Three years
· A contract is signed

RESPONSIBILITIES:
· Solely responsible for
 artist selection/curating:
 - Based on 'artist
 portfolio analysis'
· Communication:
 - Must be cost
 effective and will be
 conducted by the
 director and
 supporting staff
 (if available)

SALARY:
· Yearly base salary plus
 bonus (based on revenue
 generated)

PROFILE:
· Marketing or business
 degree with three or four
 years' work experience,
 preferably in a luxury
 industry or consumer
 goods
· Entrepreneurial mindset
· No experience in art
 market needed

▶

FINE ART

JOB TITLE:
· Managing Director
RESPONSIBILITIES:
· Completely and solely
 responsible for running
 the fine art trade
· Artist selection/curating:
 - Based on artist
 portfolio analysis
· Communication:
 - Must be cost
 effective and will be
 conducted by the CEO
 and support staff
 (if available)

PROFILE:
· Combination of
 management and artistic
 skill with ethical working
 behaviour

MARKETING ACCOUNTANT HANDLING

JOB TITLE:
· Support manager
 (marketing or
 book-keeping or
 handling)
RESPONSIBILITIES:
· Marketing:
 - Responsible in
 conjunction with the
 relevant director for
 planning, organizing
 and executing
 marketing activities
· Accountant:
 - Issuing/paying
 invoices, balance
 sheet and income
 statement, liaising
 with tax authorities
· Handling:
 - Hanging of a show,
 transportation of
 purchased works or
 exhibition works,
 delivering to client
 or exhibition space,
 and hanging

SALARY:
(depending on contract,
either outsourced or
employed)
· Project-based

Fig. 22

Case Study

GAGOSIAN GALLERY

A book on the management of art galleries would be incomplete without Gagosian Gallery. It outperforms others by every conceivable measure. Founded in Los Angeles in 1979 by Larry Gagosian, Gagosian Gallery is the world's best known and most international art gallery. With fourteen international locations, Gagosian's imperium is spread around the world. Artists exhibiting at Gagosian are the undisputed Who's Who of the art scene, as are the gallery's customers. Today, around 180 people work for Larry Gagosian, and his revenue is estimated at around $1.1 billion.

There are numerous reasons for Gagosian's success. Foremost among them is the team. With such an international operation, Gagosian relies on a team of trusted directors to run every location and liaise with collectors. Each employee is assigned to an artist; collectors are assigned to whomever they dealt with on their first contact. Gagosian reserves his personal time for only the most important collectors and celebrities. As the world's first multinational art corporation, Gagosian's organizational structure inevitably starts to feel as though it has much in common with the commercial running of a major corporation such as Procter & Gamble.

Nobody from the gallery wanted to talk to me officially, so I based my analysis on secondary sources and off-the-record interviews with employees. Looking at articles about the inner life of Gagosian by Kelly Crow from *The Wall Street Journal* and Dodie Kazanjian from *Vogue*, diversity is noticeable. Many

employees are women. Of the 180 or so entries on LinkedIn, 75% are female. There is almost no discernible common thread in their backgrounds; some worked for the powerful auction houses Sotheby's, Christie's and Phillips, while others show very little previous art market experience. Many are highly international and speak many languages; some come from an aristocratic or wealthy family background. Hong Kong's director has an MBA from Harvard Business School and worked for McKinsey. The director in the Athens gallery is an heiress from a Greek shipping family (and married into another one in 2009). Another sales person in London is not yet twenty-five and has no university education. The reason for this diversity is simple. The hiring of top staff at Gagosian is intentionally instinctive and spontaneous and, as Gagosian gallery artist Cecily Brown explained to *Vogue*, far less formal than you would expect in corporations of this size. It is Larry Gagosian himself who hires: 'He's hired people without knowing what they're going to do, just to keep them from slipping away.'

Gagosian Gallery employees have a very clear focus: sales. It is part of the DNA of the company and of every employee working for the firm. As *Vogue* was told by an employee, 'You are as good as your next deal.' Reportedly, Larry Gagosian calls his key staff several times a day. Talks are clear, concise, to the point, no small talk, no goodbye. An employee quotes a classic Gagosian line: 'I don't want to know what you're working on. I want to know when it's done.'

Hard work is rewarded. Salaries at Gagosian are very high, among the best in the gallery world. As in most sales companies, there is a bonus system. Employees earn a 10% slice of the gallery's share of revenue when they close a deal. Extra bonuses go to employees who manage to lure to the gallery an artist on whom Gagosian's eye has fallen; they get 10% of Gagosian's take on that artist's sales for twelve months. It is a fair system; those whose time is monopolized by an artist or by exhibition

preparation, and consequently have less time to sell, get a higher base salary.

To some, these sales practices might sound daunting, but sales agents from other industries will not be surprised. What Gagosian does is nothing new; it is just new to the art world. Nor does it lack humour. In an email to his staff members, Larry Gagosian once wrote: 'Today is my birthday. Please sell something.'

Cooperation Concept

5.10

In today's business world, cooperation has become a common practice: Apple with Audi, Gillette with Braun, Starbucks with Barnes & Noble. Galleries, too, must engage in strategic co-operation with art and non-art institutions to establish long-term relationships.

To promote its interests, the garage should exploit the goodwill that is often directed towards non-profit organiza-tions. Art academies in particular, sited at the epicentre of the emerging art scene, may be open to collaborative enterprise, perhaps providing work for regular exhibitions. The active art community will often include writers who can write 'What's On' or reviews for a blog or magazine. A circle of benefactors, or Friends, should also be seen not just as a revenue stream but as partners. The garage director, of course, should constantly network with established artists and social contacts to create maximum awareness through word-of-mouth.

Galleries must engage in strategic cooperation with art and non-art institutions to establish long-term relationships.

The gallery in particular should make it a priority to be at the centre of a network of partners representing excellence, not only from the art world, but also from sectors such as luxury retail or private banking. Art industry peers, of course, are the primary partnerships, and joint openings can attract new clients for both sides, as can joint showings at art fairs. Associations with a partner gallery in another major collector city, perhaps with a travelling exhibition to build up a specific artist, help to leverage both cost efficiencies and local expertise. The scope for this can be readily extended overseas, with a cooperation contract for each partner to represent the artist exclusively in the home market. Beyond the art world, obvious partners might include other retail outlets targeting

High Net Worth Individuals: Gucci and Prada, perhaps, but also premier jewellers, private banks, yacht dealers, car dealers or even restaurants. Audemars Piguet and Galerie Perrotin teamed up in December 2013 in an example of this kind of cooperation to host a party to celebrate the new works of art by French artist duo Kolkoz.

Those High Net Worth Individuals who have already had contact with the gallery are, of course, obvious targets for cooperation arrangements, and offering *carte blanche*, as discussed on page 94, can capture valuable contacts.

Finally, the most important cooperation partners are the artists themselves. They are the most valuable partners in the network, and they are rightly the group that demands the most attention. For the members of this most individual, diverse and essential group, the best personal approach is a matter of judgement for the individual gallerist.

For fine art, cooperation is crucial to enlarge the network of suppliers and buyers. At this level, it is of the utmost importance to work only with partners from A-list galleries, auction houses or dealers, those who are already established in the business and have quality contacts.

Cooperations will survive only if both sides feel that their expectations are being met, so the gallerist must manage expectations carefully from the outset. It would be wise to set arrangements on a contractual footing or, at the very least, set out clearly what the expectations and wishes are, from both sides.

Cooperations will survive only if both sides feel that their expectations are met, so the gallery must manage expectations carefully from the outset.

Case Study

DOMINIQUE LÉVY

The Swiss-born Dominique Lévy has emerged as a major force over the past fifteen years in the world of art dealing. She has come to particular public attention in recent years, with awards that include the Chevalier de l'Ordre des Arts et des Lettres from the French Ministry of Culture in 2006. Her success story has been one of partnership and teamwork, and even I struggle to put together all the names when I communicated with her in 2015.

Dominique began her career working at Sotheby's with Simon de Pury in the late 1980s. After four years at Sotheby's, she opened a Geneva gallery for the French dealer Daniel Malingue, where she met Simon Studer. Simon and Dominique formed the LS Art partnership in Geneva. They ran it for nearly eight years and remained close friends after they separated, still doing business together even now.

In the mid-1990s she met the London dealer Anthony D'Offay and went to work for him, focusing on his American artists. A few years later, François Pinault personally recruited her to launch the Christie's Private Sales department. There, she served as the first International Director of Private Sales until 2003. She then started her own gallery, Dominique Lévy Fine Art, in a modestly sized upper-floor space on East 74th Street in New York. Robert Mnuchin, another dealer, who had spent thirty-three years at Goldman Sachs, was a frequent business collaborator, and when Robert lost his partner in spring 2005, he called Dominique and invited her into an equal partnership. In August 2005 they merged their businesses.

They were a highly compatible pair. He is American, she is European. He came from the financial world, she had a finance background through her family, her father having been a successful currency trader. Both embodied art and business, he with connections to Wall Street, she to the European scene. And they had tastes in common: together they covered much of the twentieth century, Robert focusing on Abstract Expressionism, Lévy on Post-war European art. Lévy said: 'It was the feeling that one plus one equalled three.'

They successfully co-led L&M Arts for seven years, quoting their revenue in 2011 at $275 million and jumping from position thirty-seven to twenty in 2008 in *ArtReview* magazine's international 'Power 100' list. In 2010 they opened a Los Angeles branch of the gallery. Neither was under any illusion about the hard work involved in creating a team. In a June 2011 interview with *The Art Newspaper*, they were clear that it had demanded a lot of effort. Despite that, Lévy felt that the collaboration had been 'an enormous plus. I definitely could not have had such an interesting life.' Mnuchin fully concurred. 'I'll give you a tip: having a partner takes a lot of work, but it's worth it.'

Nevertheless, the partnership ended in 2012. A year later Dominique opened her own gallery in New York on three floors of a building on Madison Avenue at 73rd Street, and showed independently at Art Basel. Undeterred, she remains a strong believer in partnerships.

ADVICE FROM DOMINIQUE LÉVY

Engage in partnerships with other galleries. It's enriching.

If a partnership doesn't go in the direction you want, accept its ending. But always stay on good terms with your partner, and continue doing business together.

Case Study

FEUER/MESLER

Another partnership that drew a lot of media attention in 2015 was the merger of Zach Feuer and Joel Mesler, both recognized as leading forces on the US art scene. When I met them in their new premises in New York's hot gallery district on the Lower East Side, it struck me that the difficulties of a merger do not lie in operational processes or integration of management practices. The challenge is to identify a partner that fits. Zach and Joel wisely took their time testing out the partnership before eventually formalizing it.

Zach Feuer had founded his gallery in Chelsea in 2000; Joel Mesler, originally from Los Angeles, moved to the Lower East Side in 2007. Their professional partnership dates back to 2010 when, as two established individual players on the art scene, they did secondary deals together. 'I guess that's a very usual thing to do for gallerists. Dealing in the secondary market often involves another gallery', Zach recalls. When they realized that they got along well, they started to work more in partnership. 'It was fun and we both enjoyed the other's shows, so we did a show together', Joel tells me when the three of us sit in their 319 Grand Street space together. Their first public collaboration was in summer 2013, showcasing Jewish artists across their separate galleries. In 2014 they opened Retrospective, a gallery in Hudson, New York, which serves as a playground for the two. They also teamed up at two art fairs, Joel explaining that 'doing a fair together halves the financial risk. It really made sense for us.' A timing clash for the Hong Kong fair and a Mark Flood exhibition in Zach's gallery meant that Zach had to miss one or the other, pushing them into the next step—the formal merger.

Operationally, the merger did not cause any big issues. The IT systems were quickly integrated, all employees were transferred to the new entity (with the addition of one new hire), and a new location was identified at 319 Grand Street. The merger has reaped dividends for both partners. Both have benefited from the doubling of the contact list of collectors, museums and curators; both are now able to cross-sell new artists to existing collectors, increasing the gallery's share of wallet. 'We didn't really have any mutual collectors, so it doubled the existing collector base.' The artists are also happy, and not one has moved on from the gallery. The reputation of both galleries has also risen, because both gallerists have effectively acquired a new set of sought-after artists, putting them towards the top of the list for the organizers of the most exclusive art fairs.

Organizationally, the merger makes it easier for the two owners to commit to travel plans. 'You can't be everywhere at once. Working as a team means we can set more effective priorities and schedule our time.' With two people to share the often competing responsibilities of a gallery presence and showing at fairs, more time is available for secondary deals and for artist and collector visits. They have also professionalized their management practices. 'Before, in smaller teams, everyone was responsible for everything. Now we really have a structure. This certainly helps', says Zach. Finally, Joel points out that a team of two founders can develop their own dynamic. 'There is a lot of transferred experience happening. We just won't make the same mistakes again.'

What became clear to me when I spoke to them was that this merger is the result of consistent, measured collaboration between the two. They didn't jump in, but slowly got to know each other. They worked together for five years, consistently increasing the level of partnership every year before they finally made the move to merge. For small businesses with an owner at their heart, this approach is highly recommended. If partners do not get along, the merger will fail.

ADVICE FROM ZACH FEUER

Don't try and control everything.

If I want to buy something from your gallery, or want to show one of your artists, give me a really good deal.

ADVICE FROM JOEL MESLER

If you're a good person, fight hard to remain a good person, and if your not a good person, well, that's fine too.

Pick up a copy of *The Art of Art Dealing*, my advice to young gallerists in the *New York Observer*.

Coordination Concept

5.11

Contracts are not standard throughout the art world. In the primary market they are extremely rare. In the secondary market, where the value of works tends to be higher, they are more frequently used. The secondary market raises multiple legal issues when dealing with buyers and suppliers of highly valued works, and the need for contracts is more obvious. Galleries should, however, start recognizing the value of signing contracts across both markets.

For the gallery, a coordination concept is very important. Depending on the nature of the relationship, detailed cooperation contracts with partner galleries are useful. When artists are exchanged, contracts are critical to nailing down important issues. Who covers transport costs? What share does the primary gallery get? How long will the works remain with the gallery? Resolving these issues in advance helps to maintain lasting relationships. Even for a short-term enterprise, such as a joint showing at a fair, a detailed cooperation contract can avoid friction. Who covers the costs first? Who will take over what share of the transportation costs? Whose name will appear first on the sign over the booth?

Galleries should start recognizing the value of contracts across both the primary and secondary markets.

For collaborations with non-art institutions, both parties should agree to sign a detailed cooperation contract to confirm the strategic marketing alliance. It is useful to clarify expectations and deliveries on both sides, so that everyone's aims are clear.

If the gallery is holding an event with a High Net Worth Individual, such as a *carte blanche* show, an informal but detailed agreement must clarify all issues. The gallerist needs to be particularly clear that the show must be cost-effective and that not all personal desires can be met. As

with every show, there is a budget that must not overrun, and a contract can give the gallerist confidence in taking a firm hand.

Artists are the most frequent and most specific co-operation partners in the network. A detailed cooperation contract needs to be seen as the basis on which future collaboration between a gallery and its artists is built, and as something that protects good working relations rather than undermining or threatening them.

Coordination is probably most relevant to the fine art tier. Galleries must define effective processes and contracts in order to meet the expectations of both buyers and sellers. Here, coordination requires clear contracts between suppliers of fine art works and buyers or intermediaries. Only with standardized procedures can the gallery and its partners secure a valuable position in the market.

COORDINATION WITH ARTISTS

The relationship between gallerist and artist is often strained, partly because of the multiple roles a gallerist has to adopt. A gallerist is not only a dealer, but a financier, critic, adviser and friend. By way of return, artists question the size of the dealer's commission. Highly motivated by recognition and ego-massaging, they may question if they have the right dealer when they feel they are not getting enough exposure at art fairs, global representation, exhibitions in leading art museums and write-ups in *Art in America*. A larger gallery, higher on the pyramid, naturally has easier access to all those things, giving it considerable ammunition to tempt the artist to move across to their books. The most obvious defence against artist raids is contractual obligation. It is applied in any other industry, yet it is still astonishingly uncommon in the art world. Gallerists should not be afraid of using it.

Nor should artists. They need to take on career responsibilities beyond the production of art. The self-perception of artists as management-free can make them resistant to self-promotion, customer orientation, organization of a show

and so on. Howver, the idealistic approach and subversive reluctance to engage in management practices keeps artists from becoming excellent and reliable partners for gallerists. Artists hoping for success should note that there is a considerable competitive advantage in an artist having a sufficiently professional work ethic, and gallerists will pass over obstinately management-averse artists in favour of a more trouble-free working relationship. Maintaining excellent relations with both existing and potential customers and an overall customer focus, as well as excellent and professional organization, should not be underestimated. These are the qualities that gallerists look for within their group of artists.

Among the various issues that influence relations between artist and gallery, the following are of key importance.

BILLING

Artists need to write an invoice to the gallery for every work sold. The gallery should then transfer the artist's money to the his or her account within four to six weeks of a sale, and always after payment from the buyer. In the case of default on the buyer side, the artist should be informed immediately. The gallerist should not and must not tell the artist the buyer's contact details.

PRICES

To ensure industry transparency, artists need to give the gallerist exact prices for previously sold works, both through other galleries and direct, so that the gallerist can set prices appropriately. A transparent pricing system is in the interest of both artist and gallerist. It is the artist's responsibility to verify prices with the gallerist in case of doubt.

SALE OUT OF THE STUDIO/ART ARCHITECTURE/ REMITTANCE WORK

Gallerists must decide on a case-by-case basis with their artists the exact procedure for sales out of the studio, art architectural projects or remittance work. Depending on the

relationship of the gallery with the artist, all sales may be done via the gallery or, alternatively, the gallery can leave it up to the artist to decide.

SHOWS IN MUSEUMS AND ART INSTITUTIONS

Gallerists might introduce an artist to a museum or an art institution. This serves the gallery as a branding tool and promotes the career of the artist.

INSURANCE

Because all works are sold on commission, it is the gallerist's responsibility to insure sufficiently. The insured sum should be based on the commission value.

PROCESS WHEN CHANGING GALLERIES

Building up an artist and introducing him to the market is a cost-intensive procedure for any gallerist. It can have a serious impact on the gallery when, after years of constant investment, the most successful artist is lured away by a gallery higher up the pyramid. Contracts should be clear that in the event of an artist changing representation, the gallery may continue to show the artist for twelve months, and will earn a commission of at least 10% on all sales in the new gallery over the same period.

PHOTOS AND DOCUMENTATION OF THE SHOW

It is the artist's responsibility to provide the gallery with high-quality digital images of any work offered by the gallery for marketing purposes. Reproduction rights and copyright are assigned to the gallerist, who can freely use the materials on websites, in mailings or in other forms of publicity. It is up to the gallerist to decide where, how and in what form to use the digital images provided, but if the images are cropped or cut, the gallerist might want to consult the artist.

When an exhibition is organized, the artist and gallerist should draft together the set-up of the show. The artist can contribute ideas but must be willing to accept the final decision of the gallerist. The same goes for the title of the show, where the gallerist has the final say.

COSTS

Costs in the relationship between an artist and a gallery might relate to transportation, framing, rental for any technology, reconstruction of the gallery space, PR work, opening and advertising. For all costs, the gallery must define a clear procedure with the artist depending on their relationship.

CONTROLLING ARTIST RELATIONSHIPS

Any relationship needs continuous and thoughtful revision to stay on track and produce the greatest returns. While well-chosen and effective cooperation plays a part in creating a successful gallery, the most critical relationship is with the artist: the most frequent, the most indispensable, and potentially the most expensive element if not carefully assessed and frequently revised. My new model includes a framework to analyse the success of individual artists: the Artist Portfolio Analysis matrix, below.

Today, galleries work with a selection of artists that they consider 'artists of the gallery'. These artists are exclusively (which often means nationally) represented by the gallery. Exclusivity also means that in the event of an exhibition in a different gallery, the initial gallery receives 10–20% of the revenue.

Most of the dealers I spoke to will never change. Sadie Coles, however, has a different approach.

Taking on a 'gallery artist' is usually a long-term undertaking, accompanied by responsibilities: promoting the artist with influential people and institutions, organizing museum exhibitions or transferring the artist to international partner galleries. As years pass, during which this collaboration might

have undergone little or no revision, galleries are afraid to drop an artist from their list. Most of the dealers I spoke to will never change their programme, and consider those who follow market orientation disgracefully opportunistic. London art dealer Sadie Coles, however, has a different approach. She constantly evaluates the market and is ready to change her programme, as she explains in an interview with *Art+Auction*: 'The most difficult part is surely keeping your programme relevant, as all primary dealers rely on a close relationship with their artists, who are often of the same generation. These relationships are long-term ones, but you also need to constantly recontextualize and replenish the gallery program by keeping an eye on the general landscape.'

Changing the programme can also mean bringing some variety to the artist's percentage. Artists routinely receive the same 50%, whether young and struggling or later during the more mature and successful years. Only a few examples are known of gallerists who break this standard. In 2003, superstar Richard Prince ended his long-term relationship with dealer Barbara Gladstone to 'work independently'. After only a short time, he joined Larry Gagosian, who offered him a 60:40 split in Prince's favour. He left Gagosian in 2016. London's White Cube is also reported to negotiate varying commission splits with their star artists.

My new model introduces the notion of performance measurement and portfolio analysis as a precursor to ongoing revisions of the arrangements with any gallery artist. Performance measurement has two goals:

(1)

Analyse and document current artist performance, and decide which artists should receive more or less attention.

(2)

Develop growth strategies for adding new artists to the gallery's portfolio, while deciding on future collaborations with current artists.

Assessing the performance of artists is difficult, not least because of the balancing act between aesthetic factors and market imperatives in an environment where these two objectives are in conflict. However, performance measurement is essential for firms operating in the art market. Even though the art world has shown little interest in developing evaluative systems, they can enhance an art organization's ability to meet its objectives. Of course, there are limits to measuring the performance of artists in galleries. Difficulties in measuring qualitative outcomes, the lack of technological set-up and capabilities, weak management commitment and the lack of timely and relevant information are barriers to a successful performance measurement system in galleries. The measurement system must be as effective as possible regarding outcome, time investment, and capabilities.

When speaking about this with business consultants who constantly need to evaluate performances and companies, I worked on an adaptation of the BCG Matrix, a portfolio planning model commonly used to analyse business products. While the two dimensions in BCG's Matrix—relative market share and market growth—are usually derived from financial factors, I combined the financial and the non-financial.

To evaluate the portfolio of artists, I mapped all gallery artists onto a two-dimensional matrix and classified them into four categories based on combinations of financial performance data and artistic aspects. To correlate the exercise with the goals of an art gallery, financial performance serves as a proxy for revenue and profit; artistic aspects describe the artistic value and market appeal. Both financial performance and artistic aspects are described by a set of factors.

FACTORS TO EVALUATE
THE PORTFOLIO OF ARTISTS

	CRITERIA	DESCRIPTION AND SCALE	SCALE
FINANCIAL PERFORMANCE	REVENUE	Actual revenue	0 = 0–$25,000 5 = $25,001–$50,000 10 = >$50,001
	PERCENTAGE OF TOTAL REVENUE	Number of works sold in relation to all works	0 = 0–33% 5 = 34–66% 10 = 67–100%
	COSTS	Includes all costs allocated to an artist; in group shows, the costs should be divided by the number of involved artists and allocated to their account	0 = $10,001–$15,000 5 = $5,001 – $10,000 10 = <$5,001
	TIME INVESTED	Gallerist's perception as an average	0 = above average 5 = average 10 = less than average
ARTISTIC VALUE	NUMBER OF VISITORS	Average over four weeks' exhibition time should be used	0 = 0–50 5 = 51–100 10 = >100
	PRESS REVIEWS	Measured in actual numbers	0 = 0–1 5 = 2–4 10 = >4
	EXHIBITIONS IN OTHER GALLERIES/ MUSEUMS	Measured in actual numbers; excellent, top-class museums double-weighted	0 = 1–5 5 = 6–10 10 = >10

▶

AUCTION RESULTS	If available, in numbers	0 = price reduction 5 = stable price 10 = price growth
WORKING RELATIONSHIPS	Teamwork with the artist	0 = more difficult 5 = normal handling 10 = excellent team worker
MARKET APPEAL	Potential in reference to current, upcoming trends in contemporary art	0 = low market appeal 5 = average market appeal 10 = high market appeal

Fig. 23

According to the sum of these factors, each artist is positioned into the Artist Portfolio Analysis matrix shown below. This reveals strategic implications for the gallery portfolio.

ARTIST PORTFOLIO MATRIX

Fig. 24

POOR DOGS

Financially, Dogs perform badly, creating little revenue or even losses, but consuming large amounts of cash and time. Artistically, they add little value to the art community and lack the potential to attract new interest in their work. Such artists are candidates for release. Their share should be 30% or less. *Examples:* Unfashionable artists who bring in no added value and have never been to the top.

QUESTION MARKS

Question Marks are the problem child. They transfer huge artistic value and are widely accepted by the art scene. Their market desirability is high, with much press attention and exhibitions all round. However, financially they perform badly and do not generate much income. A Question Mark could potentially become a star. However, if not successful after years of cash consumption, they will degenerate into Dogs. Gallerists are advised to analyse Question Marks in detail to verify if they are worth the investment. In any case, their share should be around 30%, but less than 50%. *Examples:* Young artists straight from the academy, who show huge potential; older artists who are widely accepted by the art scene, possibly with the authority of a professorship, but who have limited commercial success (for example, because of huge and unwieldy artworks).

STARS

Stars are the backbone of every gallery. It should be the target of every gallery to have several Stars in its portfolio, because they generate large amounts of cash through high artistic value. They are perceived by buyers and art mediators as leading and innovative, and they receive invitations to exhibit internationally. If Stars lose the attention of the market after some years, their value endures as *Cash Cows*. Their share should be 50% or more, depending on their potential to endanger the gallery by changing representation.

As leaders in financial performance, Cash Cows exhibit a return on investment that is greater than other artists. Generating stable cash flows, they generate more income than they consume. Their artistic value, by contrast, is relatively low. The art scene regards them as 'too commercial'. Managers of Cash Cows should maximize profit and minimize investment. Their share should be around 30% but definitely less than 50%. *Examples:* Market-driven artists, more business than art, good to work with because they are always well prepared.

Of course, the matrix should not be seen as the definitive, conclusive tool to decide on future collaborations with artists. It has several limitations, such as the focus on only two categories, subjective factor input such as handling, and its assumption that each artist is independent of others. Critics might argue that artists score highly when they stick to safe trends, to the detriment of artistic progress. However, in the end it is the gallery owner who creates demand through identification of opportunity and not by blindly following the market. Gallery owners must always bear in mind that continual customer orientation would mean little or no creative development. However, the matrix serves as a simple tool for viewing a gallery's artist portfolio at a glance, and it may serve as a starting point for discussing resource allocation.

$$C^{a}se\ Study$$

CARLOS/ISHIKAWA

Carlos/Ishikawa Gallery opened in 2011 in East London in a 130-sq. m (1,400-sq. ft) industrial space as the joint venture of co-directors Vanessa Carlos and Nara Ishikawa. The gallery has two full time employees. In 2015 they participated in six art fairs. Both directors, who are childhood friends from Brazil, were trained as artists in the UK: Vanessa Carlos at Oxford and Nara Ishikawa at the Chelsea School of Art in London. After graduation, Nara returned to Brazil (and is a silent partner/investor today), while Vanessa gained gallery experience, first at Modern Art, and then for five years at The Approach while co-running Hackney's Willis Gallery. Their decision to locate in the East End was driven by finance. 'Whitechapel was a good option for us. It allowed us to keep costs low while at the same time get a big space within walking distance of other galleries', Vanessa explained. The first exhibition was *Connect. Conjugate. Continue.*, an exhibition by UK artists Ali Eisa and Norwegian-born Sebastian Lloyd Rees, who collaborate under the name of Lloyd Corporation.

In the same year, Carlos/Ishikawa exhibited Oscar Murillo for the first time in the show *animals die from eating too much—bingo!* The story of Oscar Murillo is remarkable. Murillo was born in 1986 in Colombia and graduated from London's Royal College of Art in 2012. When he did his first show at Carlos/Ishikawa, prices were around $2,500 to $8,500. In 2012, Murillo's career took off. Invited by Hans Ulrich Obrist to show at the Serpentine Gallery, he was also the first artist-resident at the Rubell Foundation in Miami, producing a collection that was bought

in its entirety by the prominent collector family. The following year his first paintings appeared successively in the three principal auction houses—Sotheby's, Christie's and Phillips—with a painting in each of the sales sessions in June and September. A commercial highlight, and price peak, was the sale by Phillips of a 2013 piece for $401,000. In the months of May, June and September 2013, Oscar Murillo's newfound popularity became evident, with seven lots totalling more than $1,600,000; then the month of October saw seven lots go for a total of more than $1,580,000. Around that time, David Zwirner Gallery announced that it would represent Murillo.

For Carlos/Ishikawa, the rise of Oscar Murillo was sudden. Vanessa: 'As his first supporters and gallery, his extreme scale-up and the massive demand was really a challenge. We had only just started trading.' The greatest danger, however, was not keeping up with the admin. 'For us, the biggest risk was selling to the wrong collectors. I think we managed quite well.'

Murillo is free to choose where he wants to show and was never under contractual obligation: 'For us, it was never about the money. I believe that it was in Oscar's best interests to show with Zwirner, and it provides his practice with the infrastructure he needs.' As an artist herself, the art and the development of the artist are at the forefront of her concerns. In fact, Murillo has not left at all. The gallery still maintains a direct working relationship with him. Carlos/Ishikawa continues to show him at fairs and in exhibitions in the gallery. Vanessa summarizes: 'Zwirner is the primary gallery, and we have fewer opportunities to collaborate with Oscar than we did before, but it's been a good and necessary step for him to get a gallery like Zwirner. I'm pleased for him.'

This example illustrates how gracefully Carlos/Ishikawa dealt with the sudden rise of one of their artists. It also provides a telling insight into a business where contracts are still unusual, which in this case has been to Murillo's advantage; as the more

established gallery, Zwirner is in a far better position to offer a five-star support structure and has considerable financial resources. These help to protect the artist from market cycles and auction results that can damage a career. Meanwhile, by exercising their guiding principle to do the best for the artist, Carlos/Ishikawa retain an equally precious integrity.

ADVICE FROM VANESSA CARLOS

Keep costs low. Don't try to keep up with the big galleries. Their spaces will always look more exclusive.

Stay focused on the art. Don't get distracted by money.

6

Conclusion

The objective of this book was to develop a new business model for art galleries. The guiding question was: 'What makes an art gallery successful?' The answer is surprising: be brave and do things differently.

I found out two things while researching gallery practice. Most galleries work along very similar lines, and most galleries do not make any profit. In fact, 30% run at a loss. What sets a successful gallery apart from an unsuccessful one is the organizational model. Changing the organizational model is the starting point to any change. I propose a three-pillar structure under which three galleries are active across the three phases of an artist's life cycle (and beyond): the garage in the shopping phase, the gallery in the decision phase, and fine art for the final phase. This allows galleries to offer a unique value proposition to their clients because they are active in every career step an artist takes, even after death.

Who are my customers? I identified three groups: Arty, Rookie and Traditional. While the Arty and Traditional groups describe existing clients, the Rookie group identifies a new set of customers that is currently under-exploited. Communication with all these customers is framed by a brand, developed by and unique to the gallery. However, changes do not stop here. A presence in both the primary and secondary markets boosts revenue, as do innovative ideas such as bundling and price variations. Costs can be cut through a flexible approach to renting premises, making a virtue of and, over time, normalizing the current trend for pop-up commerce.

Sounds good in practice, but does it apply to the real world? I believe so.

An extended value chain challenges existing competencies. New galleries will need advanced competence in management, marketing and selling; fewer art history graduates, more salespeople. The new team will engage in more cooperation—not only with partners from the art world, but also with those from other industries, who collaborate with binding contracts.

Sounds good in practice, but does it apply to the real world? I believe so. The galleries that I have presented are best-practice examples, featured to showcase how they did it. On the other hand, have I developed a foolproof blueprint to

management that every gallery needs to follow to be successful? Assuredly not. As in any business, there are myriad routes to success, and a whole world of galleries run by managers rating artists on the Artist Portfolio Analysis matrix is no more attractive than the prospect of multiple failing businesses. This book is simply intended to motivate gallerists to think about innovative challenges to the status quo.

Like all research, mine has its limitations. The greatest of these is probably that I reduced the complexity of the success of a firm to nine factors. I have not discussed such key components as the personality of the founder. There is no doubt that a great gallerist may brush aside weaknesses in management practices. Neither have I included the quality of artists; the best managed art gallery cannot be successful when its artists are simply not of the same quality. Like the personality of the founder, artists form the heart of the gallery and are a prerequisite for success.

The best managed art gallery cannot be successful when its artists are simply not of the same quality.

People are central to success in this business. Is there another industry that has such highly motivated founders with such huge passion for their product? With employees who spend hours talking with artists, working with them, holding their hands through the ups and downs? Is there any other industry that relies so heavily on trust, and where emotion plays such a substantial role? I doubt it. Gallerists are both the gate-keepers to and the backbone of the art world. I wrote this book because I firmly believe that the art world needs them, and that they will continue to exist. However, it is time to leave traditional practice behind and meet the market, and its changing demands for the twenty-first century, halfway. Gallerists need to combine culture and commerce, and this book—pro art and pro business—is written to inspire just that.

Phaidon Press Limited
Regent's Wharf
All Saints Street
London N1 9PA

Phaidon Press Inc.
65 Bleecker Street
New York, NY 10002

First edition published 2015
Second edition © 2016 Phaidon Press Limited

phaidon.com

ISBN 978 0 7148 7326 8

Designed by CeeCee Creative.com

Printed in Hong Kong